Everyday Crystal Rituals

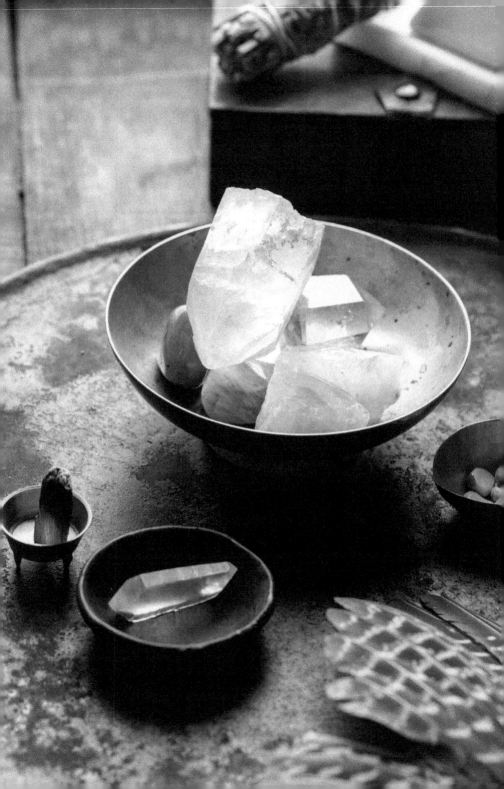

Everyday Crystal Rituals

Healing Practices for
Love, Wealth, Career, and Home

Naha Armády

ALTHEA
PRESS

Interior Designer: Debbie Berne
Cover Designer: Emma Hall
Production Editor: Erum Khan
Cover and interior photography © 2018 Paige Green. Prop styling by Alysia Andriola. Author photo © 2018 Zoë Nissman. Studio photography © 2018 Lucia Loiso.

This book is dedicated to Mother Earth.

Contents

"Cross the vastness, penetrate the darkness, go to the edges of the known world. Push beyond the boundaries as a humble and yearning student. Listen to the fire, speak to the water, see the air, and smell the earth. Gather all you can, in wisdom and light, that you may shine it back into the world, multiplied by the many facets of your unique individual soul."

—Crystal channeling from an Optical Calcite Sphere known as the "Palantir"

Introduction

Do you have a vision of how your life could be better? What would you change? What would you like to attract? What would you let go?

Ten years ago, I asked myself these questions. I had been working the same food industry job for years and had the nagging sense that I was going nowhere fast. I certainly didn't feel like I was making a positive contribution to the world. I had been in love before, but nothing seemed to stick. The creative outlets I used to be passionate about didn't excite me anymore. I looked around and wasn't inspired by where I lived. I sensed that I was on the brink of a major change.

I decided to move back to the city where I was born, Los Angeles. I had a little money saved but no real plan. Only this affirmation, which I recited to myself daily: "I am ready for a shift. Universe, please place me in a positive environment, where I can be of service."

I didn't realize at the time that this daily statement was actually a ritual, serving to call in what I needed. For years I had been a serious student of metaphysics and had trained with magical mentors, but I had always been private with my spiritual leanings. However, within months of my return to LA, I met some incredible women who were opening a brand-new healing center called the House of Intuition. Suddenly I found the doors opening to a new opportunity and knew it was time to come out of the crystal closet.

It was the change I had been looking for!

I became the crystal buyer for the store and spent my days selecting and studying stones from all over the world. I met teachers who trained and initiated me in crystal wisdom, and by 2012 I was certified as a

Trans-Crystal Therapist. This allowed me to begin using crystals in one-on-one sessions, placing them on clients to assist their healing processes. I created crystal grid ceremonies, putting my ritual training to work and helping students work on specific intentions. I was doing work I loved and helping others in the process.

The more I worked with crystals, the more I could feel their energy and see the results of their influence. In my own life, I could feel things falling into place, and I found myself intuitively knowing which stones could help specific clients work through their circumstances. People came in stressed out, worried, or drained, and left replenished and renewed. It was obvious to me that the crystals had positive energies to share with those who were open to them.

Whenever someone comes to see me for a crystal healing, I begin the session with this prayer: "May this person's path be one of fulfillment, success, love, happiness, and health." These are the five qualities that lie at the center of our well-being. Although the outer details of what we want may change over time, these foundational aspects remain constant. Yet sometimes they become diminished, buried, or blocked.

The first step to getting back on track is to lift the walls, blockages, and stagnant energies. Once our energy is free to move, it can flow positively through our heart, which allows us to love ourselves fully, attract love, and connect deeply with others. Prosperity is another piece of the puzzle. While we need not be greedy, there is no reason to think of money as evil. It is the modern means of exchange, and it wants to flow just like every other type of exchange. When we radiate self-worth, we attract opportunities and abundance. Our home is an extension of our energetic field—it's where we get a sense of belonging and grounding, and it's where we nurture ourselves. When we incorporate rituals into our daily

life, we create a space that is beautiful, uplifting, and inspiring, and this helps us live to our fullest potential.

Whether you're new to working with crystals or they're already a big part of your life, you will discover new methods and rituals in this book. Once you incorporate them into your daily routine, things are bound to shift for you. First we'll examine the healing powers of crystals and learn how to select crystals and ask and receive through rituals and intentions. Then I'll outline 60 rituals for Love, Abundance, and Home. In these chapters, you'll find both simple and more intermediate rituals. Allow yourself to gradually try new rituals as you learn more and feel ready to go deeper. In part 3 of the book, you'll find profiles of 100 power crystals that you can use in your various rituals as you grow your practice.

The rituals in this book will show you how to release what doesn't serve you, realign with your truth, make your home a sacred, nurturing space, and awaken your ability to live in fulfillment, love, and abundance.

Let's get started!

The Way of Abundance

The following pages contain everything you need to know about getting started with crystals. You'll learn about their healing properties, how they can help you, how to best channel their energy, and how to care for them. You're entering into a mutually beneficial relationship with these stones, and we'll cover all the basics so your crystal work can be both effective and rewarding.

Crystals can elevate our healing, assist in meditation, and help us achieve our goals, but they need to be taken off the shelf in order to work. Let's start by exploring how crystal healing works and how to get the most from your crystal rituals.

Calling on Crystals

A Gift from the Earth

Crystals emerge from deep underground to show us what a magical world we live in. A key concept of magic is the idea of "as above, so below," meaning that what exists in the physical realm is a reflection of what exists on the higher planes. Crystals can connect us to those higher planes and help us unearth the gems of our gifts and abilities that reveal our hidden potential. Every crystal has an underlying, organized pattern that gives it its unique structure and shape. For instance, Quartz—one of the most widely known crystals—occurs in clusters and individual terminated points with six sides and faces, making it easily recognizable. Other stones, like Jasper, Agate, and those that do not form into crystal points, might not look like crystals, but they are. They are simply microcrystalline: Their crystal structure is too tiny to be seen by the naked eye. (In this book the words *crystal* and *stone* will be used interchangeably.)

Consider the structure of your life for a moment. Your relationships, career, behaviors, home life, and ideas are based on underlying patterns. Those patterns are established by your experiences, environment, and circumstances. When the patterns become disorganized, outdated, or stagnant, growth is difficult, and you'll often find yourself stuck in a rut. But when the patterns are elevated, organized, and relevant to your present and future, then your foundation becomes strong and you're capable of healthy growth and evolution.

Crystals provide a perfect energetic blueprint; it's encoded into their crystalline structure. Working with crystals is metaphysical, or "beyond the physical." As empathic beings, humans are affected by the energies around them. Think of times when your mood has shifted after being around negative or positive people or situations. Things rub off on us, for better or worse.

And therein lies the power of crystals. Because crystal energies are clear, natural, structured, and energizing, we can take on these qualities simply by having them around us. Crystals can help awaken hidden

abilities and activate positive qualities that might be lying dormant within us. Crystals have lived under the ground for thousands, if not millions, of years, and their emergence serves as a beautiful example of how to unearth our gifts and talents and bring them into the light.

Energy and Vibration

Energy runs throughout everything. Even the most static, dense objects are made of individual vibrating molecules of energy. In the East, this principle has been accepted for thousands of years. This life-force energy is known as *prana* in Sanskrit, *chi* or *qi* in Chinese, and *ki* in Japanese. When your energy is moving, flowing, and balanced throughout your physical body, it is positive; when it is stuck, blocked, or trapped, it is negative.

Vibrations are waves and can be carried through sound, light, aromatherapy, touch, hands-on healing techniques, like Reiki, words and affirmations, and pictures and symbols. When these vibrational techniques are used for healing, they are called modalities. Most healing modalities can be made even more powerful with crystals.

Energetic vibrations can be directed, and we can use crystals to do this by pointing the crystal in the direction we wish the vibration to move. Other ways we can direct energy is by using our breath or visualization techniques. Working with crystals will deepen your understanding of vibrational healing and how to control and move energy.

Every crystal has its own energetic frequency or vibration. Some stones are high frequency and can help you open your mind and connect with heightened awareness. High-frequency stones project their qualities to help you feel energized. They tend to be more easily felt and are great stones to work with as you are getting used to crystal vibrations. They can lift your mood, encourage inspiration, and help you achieve breakthroughs. Holding a high-frequency stone may cause a tingling sensation in certain areas of your body. Some common high-frequency crystals are Quartz, especially varieties like Lemurian, Nirvana, and Rutilated Quartz.

TUNING INTO THE FREQUENCY

Try focusing on the energy of your heart. With your eyes closed, imagine a heart-centered positive vibration in the middle of your chest. Now see if you can move it, using visualization, up toward your head and down again, like a figure eight. You can also move this vibration out of your body. Focus once more on your heart center. Then try moving it forward out of your body toward a person or object. Let it flow back into you again like a figure eight. Use your breath to help you, sending the energy one direction as you exhale and drawing it back toward you as you inhale.

Next, hold a crystal in your receptive (nondominant) hand to see if you can feel anything from the stone. Close your eyes, take a deep breath in, and just relax. Don't get discouraged if you don't feel anything at first. As you become more accustomed to subtle vibrations, it will get easier to feel crystal energy. The more you work with stones, the more attuned you'll become to their frequencies.

Crystals with a strong visible termination (natural point) tend to be high frequency.

Crystals that have a lower frequency can anchor your energy when you need to come down to earth. These crystals are good for helping you stick to your goals and maintain your healing process. They also tend to be extractive rather than projective, meaning that they help absorb blockages, pain, and things that we want to let go of. Extractive grounding stones are good for releasing stress, calming the mind, and creating boundaries. They are often protective, and while you may not feel an energy buzz (as with high-frequency stones), they create a sense of safety and stability when they are held and can help you feel supported in your endeavors. Crystals like Jasper and Agate are good examples of lower-frequency crystals.

The Five Elements

Our world is comprised of four primary elements: Fire, Water, Air, and Earth, plus a fifth element, Spirit, which is present in everything and connects the other four. These five elements occur throughout all traditions and have a long history in metaphysical teachings. They each correspond to a different layer of the subtle body (e.g., the mental body, emotional body, and aura).

Crystals are primarily associated with the element of Earth—they are literally from the depths of the earth—but different crystals also resonate with secondary elements. In the Power Crystals profiles (see page 135), I include the elements associated with each crystal.

FIRE

The element of Fire corresponds to our etheric body, which is the first energy body above the physical body. The etheric body holds our patterns and is the framework on which our physical body and our identity are built. The etheric body can hold traumas experienced in the physical body, so healing is profound on this level. When you are stuck in a rut, identifying with a negative self-image, or lacking motivation, you likely have blockages in your etheric body. Stones that correspond to Fire like Citrine (page 163), Peridot (page 200), and Pyrite (page 206) help rebalance and align this important framework of the self.

WATER

The element of Water relates to the astral body, also known as the emotional body, through which we process our moods and feelings. Our emotional body also governs our digestion and our creativity. Stones like Agates (page 137) and Rose Quartz (page 210) correspond to Water and help balance the emotional body, making great heart healers and mood elevators.

AIR

The element of Air corresponds to our mental body, through which we express our thoughts, opinions, and ideas. In the mental body we hold the information that we take in each day. It is where we worry, speculate, get anxious, and overthink. Stones that correspond to Air like Amethyst (page 140) and Fluorite (page 173) help clear the mind and keep our brains balanced.

EARTH

The element of Earth corresponds to our physical body, the densest part of the self. The frequency of the physical body is low enough that we can see it with our eyes. It is the element of the final manifestation of energy through the other bodies. Grounding stones like Jasper (page 180) and Smoky Quartz (page 221) are great Earth stones that can help us not only energetically but physically as well, amplifying the strength of our physical body's ability to heal.

SPIRIT

The element of Spirit corresponds to our spiritual body through which we connect to our highest self. Clear Quartz (page 102) is a stone that is ruled by the element of Spirit. When we are aligned with our spiritual body, we can perform as the best version of ourselves. It is also through the spiritual body that we come closer to achieving an understanding of the Divine.

Crystals and Chakras

Your body has an energetic system that includes seven centers called chakras. *Chakra* is the Sanskrit word for "wheel," and when these centers are open and turning, they are believed to distribute life-force energy throughout the body. The seven main chakras run from your tailbone to the crown of your head. Each chakra vibrates with a different color frequency, and therefore it can be attuned with crystals that match its color.

THE ROOT CHAKRA resonates with red, black, brown, and silver crystals. This is the center for stability, grounding, protection, and security. It is located at the base of your spine.

THE SACRAL CHAKRA resonates with orange and peach stones. This is the center of your creativity, sexuality, passions, and desires. It is located about a hands-width below your navel.

THE SOLAR PLEXUS CHAKRA resonates with yellow, gold, and amber stones. This is the core of your being. It is the center for your self-worth, confidence, and will. Your solar plexus is located below your sternum.

THE HEART CHAKRA resonates with all shades of green and pink. This is the center for love and compassion and helps regulate all the other chakras. It's right in the center of your chest.

THE THROAT CHAKRA is activated and balanced by blue stones. It is the center for communication, ideas, and learning. It's important to note that this is the center for listening and seeing, as much as it is for speaking. This chakra is at the center of your throat.

THE THIRD EYE CHAKRA resonates with purple and indigo stones and is the center for intuition, higher wisdom, visions, and inspiration. It is just above and between your eyebrows.

THE CROWN CHAKRA resonates with clear, iridescent, and white stones. It is the center through which we connect to our higher self, our soul purpose, and our spiritual understanding. Your crown chakra is at the very top of your head.

Remember that your chakras are not on the front of your body, they are centers within you, accessible from both the front and the back. Each stone has a chakra or chakras associated with it. But the stone is not placed only on that chakra; it may be placed anywhere on the body.

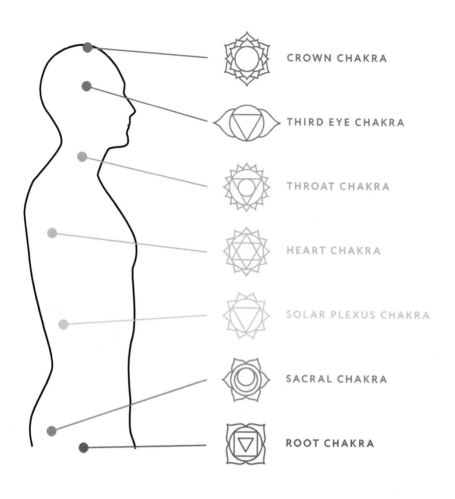

CROWN CHAKRA

THIRD EYE CHAKRA

THROAT CHAKRA

HEART CHAKRA

SOLAR PLEXUS CHAKRA

SACRAL CHAKRA

ROOT CHAKRA

How Your Helpers Help You

Crystals are transmitters capable of storing data, meaning they can hold a program that you define. This does not mean that you are forcing your will upon the stone, but simply that you are setting one specific intention

for that crystal to help you. A programmed crystal then amplifies this message and sends it out to the universe.

It is important to understand that crystals do not do the work for you. Rather, they help you resonate with the frequency that you desire. A program is a two-way contract, and you have to do your part to make sure that you are also working to project the same frequency.

In the same way that a tuning fork is used to help a musician find the right harmonic note with their instrument, a crystal helps the subtle bodies find the right frequencies for those areas where they have become disharmonic or "out of tune." Many times this means having the crystal as close to the physical body as possible. You will often want to have your crystals make contact with your skin. Crystals that are shut away in a drawer cannot work for you very well.

If you are carrying crystals throughout your day, give them a squeeze from time to time. Rub them between your fingers and hold them up to their corresponding chakra, take a deep breath, and continue on with your day.

For other purposes, crystals do not need to be against your body but just in your home or field of influence so they can work on the energy of a space. You can even keep them under your pillow while you are asleep, where they will work on your subconscious mind and imbue your dreams with wisdom and knowledge.

Beauty and Attraction

Pretty much everyone can agree that crystals are beautiful to look at. Some crystals will simply catch your eye. But finding the right crystal for you can be more about "feel" and less about "look." Dropping a stone into the palm of your hand and finding that it fits perfectly can be a good way to know that it will work well for you.

As you receive or purchase new stones, set aside some time to sit with them. Take them into full sunlight and look at them carefully to see all that

they contain. Connect with them on a level beyond looking up the meanings. Give yourself a few days to carry around a new stone exclusively so you can get used to the way that it feels.

RAW AND POLISHED STONES

Stones can be raw just as they are when extracted from the earth, or polished and cut into shapes. Often they are tumbled, which gives them a natural shape and shine. There is a time for raw crystals and a time for polished. Think about your purposes. If you are just beginning a new project or relationship, a raw stone might feel more appropriate because it symbolizes raw potential that can be molded into something later. A stone cut into a shape can add another symbol to its purpose, such as an egg-shaped crystal for rebirth or fertility, or an obelisk for harnessing energy.

CRYSTAL DEVAS

You can also introduce yourself to the Deva of the crystal, which is said to be the crystal's spiritual consciousness. To do this, sit with the crystal, close your eyes, and allow yourself to be open and receptive to any presence that you might feel connected to it. You can make very simple requests or ask questions in your mind, such as, "Help me to know you," or "What can you help me with, and how should I honor this task?" Listen for the answers and feel the natural connection forming between you and the stone.

GODS, GODDESSES, AND DEITIES

Crystals can connect us to higher-frequency beings, such as gods, goddesses, and deities. These beings can all serve as spirit guides and facilitate our intentions by giving us an energetic pattern to resonate with, just like crystals do. Invoking gods and goddesses can amplify the power of your crystal rituals by connecting you to an archetype of what you want to achieve. It can also help awaken your own inner divinity. We'll invoke such beings in rituals throughout the book.

Crystal Clear Intentions

Intention setting leads to the manifestation of what you want in life. Intentions are an integral part of working with crystals and experiencing their Divine power.

The clearer you are in setting your intention, the better the results will be. Mental clutter and indecision do not lend themselves to successful manifestation. Here are the four stages to creating results through intentions:

1 **INSPIRATION.** This is when an idea comes to you. It is the light bulb turning on. It is a realization that there's something within you that is ready to grow, be shared, or be born. Crystals can help open the channels to connect you with higher sources of inspiration. Just as a beautiful piece of music or art can be inspiring, crystals can inspire us as fascinating creations of nature's art.

2 **INTENTION.** Here is where you use your creativity to decide how to channel your inspiration. Crystals help you go beyond your own limited understanding of your capabilities. They can raise your intentions to even higher levels. Choose a specific stone to hold an intention, and say out loud, "Help me align with my highest potential."

3 **ACTION.** This is where you do the work to bring your intentions to life. Crystals will help you by serving as physical reminders to keep you focused, on track, and keep your energy moving in the right direction. Every time that you see or hold a crystal that you've programmed with an intention, you will reconnect with your goal.

4 **FRUITION.** This is the stage in which your intention becomes your reality. One of the most important things to remember in this stage is gratitude.

THE CYCLE OF THE MOON

Syncing your intentions with the Moon can make your intentions more powerful. Throughout the book, I suggest the ideal Moon phases for certain rituals.

There are four phases to the Moon cycle:

NEW MOON (UP TO 24 HOURS BEFORE AND AFTER): This is when the Moon is dark in the sky. It is the best time to go within, set intentions, begin new projects, set up altars, and do "day one" work.

WAXING MOON: This is the period between the New Moon and Full Moon. It is a time for taking action, increasing energy, ramping up productivity, and focusing outward.

FULL MOON (UP TO 24 HOURS BEFORE AND AFTER): This is the Moon at its fullest power. It is the time to charge your crystals, center yourself in gratitude for the last cycle, and take inventory on all that you have accomplished.

WANING MOON: This phase occurs between the Full Moon and New Moon. It's time to release, detox, decrease energy, do dreamwork, focus inward, and prepare for the New Moon phase.

Meditation

In order to set powerful intentions, you'll need to get very quiet and listen to your higher self. You can do this through meditation or any peaceful ritual, like taking a bath or walking in nature. Crystals are of the earth, so elements like Water, Air, and Earth complement crystal healing.

While invocation and prayer are acts of request, meditation is an act of receptivity. You are listening for the callings of your higher self. Many of the rituals in this book incorporate meditation. Your position for meditation will depend on your individual body and the specific type of work that you're doing.

SITTING

A sitting meditation is best when you are directing the work or being proactive in the visualization. It is also helpful to do a seated meditation if you find yourself falling asleep too easily when you lie down. Sleeping is not meditation!

Two methods of sitting are:

1 Sitting cross-legged on a cushion on the floor. (This is traditional but not comfortable for all body types.)

2 Sitting in a chair with both feet flat on the floor, arms uncrossed (no twisting or hunching!).

For both positions, sit with your spine straight and your palms facing up and gently resting on your lap.

LYING DOWN

A lying down meditation is best when you want to go deep into the subconscious. If you are simply being receptive and passively observing the ritual but not directing it, try this position. Lying down works well when you want to place multiple stones on your body.

It is best to avoid doing this position on your bed, as you are likely to fall asleep. Lie on your back on a mat or blanket with your legs straight and your feet uncrossed, a few inches apart. Have your arms by your sides. Ideally, your head will also be on the floor. If you have back or neck pain, you can use a small pillow or rolled towel under the neck or knees to support your spine.

CARING FOR CRYSTALS

Crystals are delicate and therefore need to be handled with care. They also benefit from regular cleaning, both physically and energetically. Physical cleaning removes dust and body oils, while energetic clearing can remove any negative frequencies the stones may have picked up.

For physical cleaning, the old standard method of soaking crystals in saltwater is no longer recommended, as salt is a corrosive mineral and can damage your crystal. Also, soaked crystals can take water into their crevices. This can cause them to develop rust if they have any iron content. Beautiful clear stones can develop brown streaks of rust after being soaked in water. Not what you want! The best method is to wash the stones gently under running water and immediately dry them with a soft towel.

Some stones should never be placed in water because they are soft or can rust. These include Angelite, Selenite, Malachite, Pyrite, and Chrysocolla. Luckily there are plenty of other ways to clean and charge crystals using the four other elements.

Check the associated element for each crystal (see Power Crystals, page 135) before clearing it.

AIR

Diffuses and disperses negative ideas, conversations, and thoughts.

- Smudge crystals with incense, sage, palo santo (holy wood), or cedar.
- Perform a sound bath with singing bowls, rattles, or bells.
- Use feathers and fans to generate wind and "air out" any stagnant energy.

EARTH

Draws off and absorbs feelings of heaviness.

- Lay crystals gently on top of a bed of coarse salt on a plate or in a shallow bowl.
- Place crystals on a bed of herbs, such as lavender, sage, or eucalyptus.
- Use other stones—such as Kyanite, Selenite, and Himalayan Salt—to clear your stones. (Place your crystals right on top of a clearing stone or pass the clearing crystal over your stone in a sweeping motion.)

FIRE

Transmutes old outdated energy and clears old patterns.

- Place the crystal in candlelight.
- Lay your stone in sunlight for 20-30 minutes. (Do not leave Kunzite, Amethyst, Fluorite, or Rose Quartz in direct sun.)

WATER

Dissolves and dilutes negative feelings and emotional blocks.

- Bathe crystals in streams or creeks.
- Dip your stone into a snowbank.
- Moonbath: Since the Moon affects the bodies of water upon the earth, a Moonbath is an effective way to clear and charge your crystals. You can place them outside overnight or leave them on a windowsill.

SPIRIT

Brings anything out of balance back to center.

- Violet Flame Visualization: Imagine a purifying violet fire surrounding the stone and clearing away any energetic debris.
- Set an intention or affirmation.
- Place the crystals in a geometric pattern or mandala.
- Take the crystals to your sacred places, such as temples, churches, or nature.
- Perform Reiki or other healing modalities where energy is directed by the palms of the hands.

Asking and Receiving

With clarity of purpose, you can put your intention out into the universe by writing it down, speaking it clearly, or visualizing it. There is power in the spoken word, and it is suggested that you state intentions out loud whenever possible.

The rituals in this book use a combination of prayers, affirmations, and mantras. These are guidelines and suggestions, not hard rules. The most effective prayers are those that are spoken from the heart. Feel free to change the wording of any of the prayers or mantras in this book to best suit your needs and personality.

Many of the statements also end with the affirmation, "So it is." Depending on your spiritual tradition, you may want to use a different closing, such as, "Amen," "Sat Nam," or "So mote it be." They all accomplish the same thing by affirming and releasing your statements to the universe.

Being truly open to receiving means not limiting yourself based on the specific details of what you want. Resist the urge to control or micromanage Spirit. Instead, simply be a seeker of wisdom, a conduit of light, and a vessel through which Spirit can touch and guide you.

Be open to what will be best for you rather than what you think you need. You can ask for the blessings to align with your greatest good, and then allow the windows of your mind and your heart to be open and see what flows your way.

There are no "bad" crystals, and crystal healing will never make you more blocked. It can only assist you in achieving greater clarity and alignment.

When you have completed the ritual of your choosing, take a deep breath in and out. If your eyes have been closed, you may open them just partway as you let yourself return gently to full consciousness. Slowly move your hands and feet and make sure you are fully back in your body before you stand up.

If you have placed stones on your body, you may cleanse them, otherwise you may place them back on an altar or grid to keep them charged for the next time.

Setting Up Your Rituals

Crystals are even more effective when used in combination with representations of the elements.

Here are some additional items that you will use in the rituals in this book:

CANDLES

Candles are used to ignite intention, draw light into manifestation, and transmute stagnant energy. Candles can also serve as a conduit between the stones and your physical body. It's best to use seven-day prayer candles for your crystal rituals, which you can find at the grocery store or online.

Any time you light a candle with intention, you are igniting a process that you will want to see to completion. In order to get there, you will need to burn the candle all the way out. Seven-day candles are intended to be left burning, but for safety's sake, do not leave them burning unattended. To continue holding the intention, you can snuff the candle out rather than blow it out and relight it as soon as you return. You can also place the candle on a coaster or in a small dish of water when it starts getting close to the end.

PALO SANTO, INCENSE, AND SAGE

Smudging is the practice of burning sage, resin incense, or palo santo to energetically clear an area. After lighting incense, a bundle of sage leaves, or a stick of palo santo, you can blow it out while it smolders. Then waft the smoke throughout your home or around your body to clear any negative

IMPORTANT TERMS FOR
CRYSTAL HEALING

ACTIVATOR: A crystal that's used to activate a grid or other arrangement of crystals. Usually programmed by the user. Clear Quartz points (single-terminated)work best.

AMULET: An object programmed to ward off negative energy.

AXIS: The centerline of a crystal, from the base to the termination.

CABOCHON: A stone that has been cut into a flat shape for jewelry setting. Also works well for crystal healing on the body.

CHATOYANCY: The reflective effect found in certain stones like Tiger's Eye (page 232), Apatite (page 145), Aquamarine (page 147), and Moonstone (page 193).

CRYPTOCRYSTALLINE: Another word for microcrystalline, this refers to stones with a crystal structure that can only be seen under a microscope, like Agate (page 137), Jasper (page 180), and Rose Quartz (page 210).

DOUBLE-TERMINATED: A crystal with a natural point on both ends that did not break off a matrix. A single-terminated stone only has one point.

GENERATOR: Crystals that stand upright are called generators. They often serve as power pieces on a grid or altar. They help to project energy outward.

GRID: A crystal grid is a method of creating a sacred space by placing stones in a geometric pattern to broadcast a specific intention. A charging grid is explained in the first ritual in chapter 4 (see page 109).

INCLUSION: When an additional mineral or embedded object is found in a stone, such as Rutile (page 212) or Chlorite in Quartz (page 160), or Epidote in Prehnite (page 168).

MACROCRYSTALLINE: Stones with a crystal structure that can be seen with the naked eye, like Quartz, Amethyst (page 140), Beryl (page 147), and Tourmaline (page 234).

MATRIX: The host rock that a crystal grows on; for example, the brown base of an Amethyst cluster.

PALM STONE: A crystal that fits in the hand with a natural shape. These are larger than tumblestones and typically hand polished.

PRANA: Life-force energy.

PROJECTIVE HAND: This refers to your dominant hand (the hand that you write with). This hand is used when sending a program to a stone or directing energy outward.

RECEPTIVE HAND: This refers to your nondominant hand (the hand you don't write with). This hand is used when receiving energy or scanning and picking up subtle vibrations.

SCRYING: Also known as crystal gazing, where the focus is softened so that clairvoyant visions may be brought forward from the subconscious and projected onto the surface of a crystal.

TALISMAN: An object programmed with a specific magical purpose.

TERMINATION: The natural point of the crystal.

TOWER: A tall crystal with a flat base that can be either cut into a tower shape or form a natural point.

TUMBLESTONE: A small, usually inexpensive stone that has been smoothed and polished by a rock tumbler. These are good for keeping in your pocket or placing on a grid.

WAND: A crystal point with natural terminations, or a stone that has been cut into either single or double terminations and used to direct energy.

energy out. This is best done with a dish to catch the ashes, and with all of the windows or doors open. I recommend smudging on a sunny day, as the sun will help transmute anything that's released.

ALTARS

You don't want to crowd your altar; the items on it should have room to breathe. This is a place to keep your crystals to charge, to light candles, and to focus your intentions and prayers. You may keep other objects for meditation and ritual here, such as bells or singing bowls, statues, figures, or photos of guides or loved ones. You may place offerings of fruit or flowers here as a sign of gratitude. Occasionally you'll want to write down intentions or affirmations, so keep some paper and a pen nearby. For any rituals involving fire, you will need a fire-resistant bowl, but matches should not be kept on your altar. When setting up an altar space, it is nice to have a cloth or table to designate the boundaries of the altar. Be careful not to let any misplaced objects clutter this area.

TALISMANIC VS. HEALING STONES

Crystals that are used on altars, for protection, or placed in the home or on crystal grids are talismanic stones. A talisman is an object that has been ceremonially charged with a specific intention as opposed to healing stones to place on the body. Crystals cut into hearts and animal shapes are crystal talismans.

Tumblestones, flat pieces, palm stones, and raw crystals work better as healing crystals. These work directly on the physical body by aligning our frequencies with those that are healthy and have high vibrations. They can be carried in a pocket. (Some people even like to place them in their bra.)

Crystals can also be wire wrapped and made into pendants. This is a good way to keep them close to your body, and you can even use a length of chain so they'll hang right over the appropriate chakra. Crystal jewelry may be either healing or talismanic, or both.

Love, Money, and Home

In the upcoming chapters you'll find suggested stones for creating love, manifesting abundance, and raising the vibration of your home. The rituals shared here range from easy to advanced and will help you heal on many levels, from working on your inner self to creating outward change to strengthening your spiritual practice.

Love can mean a multitude of things. It ignites the heart, stimulates the emotional body, and encompasses desire, romance, friendship, and compassion. Love accelerates internal healing through its positive energy, and external healing through connection, empathy, and understanding. All of these aspects of love begin with heart-centeredness.

CHAPTER 2

Rituals for Love

THE 20 CRYSTAL RITUALS IN THIS CHAPTER are powerful heart healers and designed to attune you to the highest love frequencies. Love rituals assist in attracting, manifesting, and strengthening relationships of all kinds, and helping you feel and create more love in the world. Incorporating these rituals into your life and aligning your heart through the use of crystals will allow you to reflect your highest loving potential.

Crystals and Love

Crystals are nurturing to the emotional body and can open and activate your interior channels to give and receive love. Most green and pink crystals, from Emerald and Ruby to Green Jasper and Rose Quartz, are heart chakra stones. This means they resonate with the vibration of heart-centeredness, and can assist you in doing the same. Stones like Kunzite, Pink Lemurian Quartz, and Aventurine are projective and amplifying, and they can energize and motivate you in your quest for a deeper and fuller expression of love.

Crystal frequencies can also help you release unhealthy patterns, stuck energies, old heartaches, and other obstacles to giving and receiving love. Stones like Agate and Calcite are soothing and extractive, and gently draw off pain and heartache. Stones like Rhodochrosite and Peridot are helpful when you're going through a transition period and need to center yourself and regroup. Grounding heart chakra stones like Ruby Fuchsite and

Rhodonite help you regain stability when you find yourself going off the emotional deep end.

To attract love, you begin by finding love within yourself. If you feel blocked or doubtful, the first step will be to gently open your heart and soul to the idea of self-love. From there you can build and begin to broadcast love outward. This attracts others into your life who are also on that wavelength.

The body has many other energy centers. One of these is the higher heart chakra, sometimes called the thymus chakra. Located halfway between the throat and heart centers, this center associates with your soul purpose. Through an activated higher heart, we can communicate our heart's desires more clearly and receive visions of how our lives can make an impact on a larger scale, whether for our community or globally. Its color is blue-green and stones include Turquoise, Chrysocolla, Chrysoprase, and Dioptase.

A strong heart center supports the rest of the chakra system, as it lies in the middle with three chakras above and three below. From this strong and radiant core, you can grow outward in a more loving vibration and also truly identify with your own pure essence.

Just as each human is unique, so is every crystal. They share a perfect underlying crystalline structure but develop into their own size, shape, color, and clarity. When we recognize this in the stones, we can then see it in ourselves. This is one of the ways that crystals help us accept ourselves for who we are, forgive ourselves for our shortcomings, and find gratitude for our gifts and what makes us special.

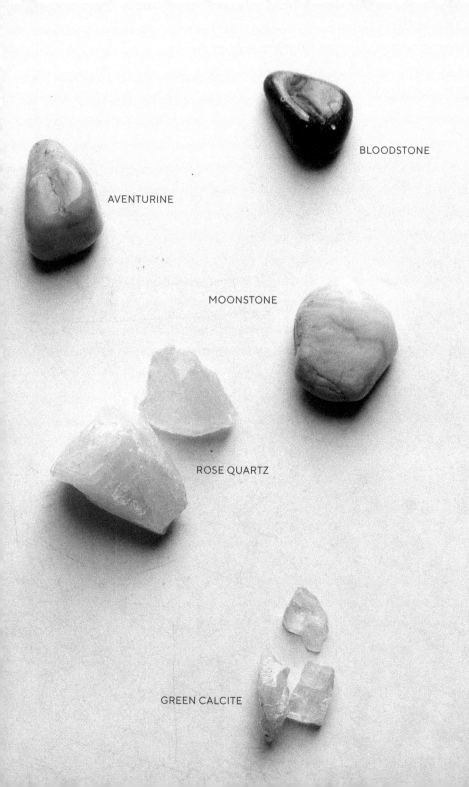

BLOODSTONE

AVENTURINE

MOONSTONE

ROSE QUARTZ

GREEN CALCITE

TOP LOVE CRYSTALS

BLOODSTONE

With red specks set against a chalkboard-green background, Bloodstone is a stone for healing the love between family members. It's used for ancestral healing, familial support, and anything passed down from one generation to the next. Meditate with bloodstone to help heal those areas.

AVENTURINE (PINK OR GREEN)

Aventurine is an all-purpose heart healer. As it sparkles with tiny flecks of mica, it awakens passion and inspiration. Its uplifting energy opens the channels for motivation and encouragement. Aventurine is a good stone to take with you when you are trying to meet someone new or going on a date.

MOONSTONE

Moonstone is one of the most powerful stones for tuning the emotional body. It can help relieve moodiness and calm the fluctuation of those affected strongly by the Moon's cycles. Use it in your love rituals to call in the Divine Feminine and get in touch with your inner goddess.

ROSE QUARTZ

Rose Quartz is the best-known crystal for the heart. When experiencing any kind of emotional difficulty, Rose Quartz can be that gentle friend that is there to comfort you. Place Rose Quartz on your heart and let its soothing vibration wash over you.

GREEN CALCITE

Green Calcite acts like an emotional sponge, drawing off emotional tension or discomfort. When you are ready for an act of self-love, place Green Calcite on any area of the body that feels sore due to emotional stress and let it rest there. Visualize the stone absorbing the discomfort. After 10 minutes, remove the Calcite, rinse it under water, and dry completely.

PREHNITE

Prehnite is a lime-green stone that often contains Epidote inclusions. This stone is said to heal the healer and is perfect to use when you have exhausted yourself giving your energy away to others. It's a stone for those who love deeply. At the end of a long day, a meditation with Prehnite can help restore focus back to the self.

PERIDOT

This yellow-green August birthstone connects the heart to the solar plexus and is one of the best stones for accepting change. Using Peridot on the body when dealing with separation or breakups can support the sense that all will be okay through the transition period. This stone can make letting go a little easier as it turns your focus toward self-love, self-respect, and dignity.

PINK BOTSWANA AGATE

Layers of silver, white, and peachy pink make Pink Botswana Agate a stone that connects the heart chakra to the crown and the sacral chakras. This allows gentle nourishing love to flow throughout the entire system and can assist in bringing more creativity into your life. When relationships get stale and need a boost, carry Pink Botswana Agate with you to get the juices flowing again.

RHODONITE

Rhodonite is one of the best stones for grounding out-of-control emotions. When you're feeling overwhelmed, obsessive, or dealing with too much emotional baggage, carrying Rhodonite helps release those burdens. It connects the heart with the root chakra and helps get your feet back on the ground so love can flow without going overboard.

RHODOCHROSITE

Rhodochrosite is a go-to crystal for deepening self-love. It harmonizes the heart and solar plexus and helps you remember your worth and value. If you feel the need for validation from others, or have a hard time receiving love, placing Rhodochrosite on your heart center reminds you that you are deserving and lovable.

PINK BOTSWANA AGATE

RHODONITE

RHODOCHROSITE

PREHNITE

PERIDOT

MANGANO CALCITE

RUBY FUCHSITE

KUNZITE

NIRVANA QUARTZ

PINK LEMURIAN QUARTZ

MANGANO CALCITE

Mangano Calcite is particularly useful for Reiki practitioners and hands-on healing modalities. It helps transmit healing love energy from one person to another. It harmonizes the heart and crown chakras and radiates the frequency of unconditional, nurturing, nonjudgmental love. Place it on the heart or hold it in the hand during meditation.

RUBY FUCHSITE

Green Fuchsite with Mica serves as the matrix (see page 21) for hexagonal shaped Rubies, which are classic gemstones for love and desire. This crystal links the heart with the crown chakra and helps us to lift up out of heart heaviness and into a more elevated and hopeful outlook. Ruby is also grounding and protective, and a good touchstone to keep at hand when you are ready to make a deeper commitment.

KUNZITE

Kunzite is a translucent lavender-pink striated stone that has one of the most powerful energies for blasting through any blocks and creating new pathways to love. Place it with the striations pointing up and down on the heart chakra for a powerful dose of crystal love energy.

PINK LEMURIAN QUARTZ

With raised bar-like coding on the sides, Pink Lemurian Quartz is said to carry the teachings of the Lemurian wisdom keepers. This can be used for understanding past lives and love across different dimensions. Rub the side of a Pink Lemurian Quartz during meditation to uncover information about your soul mate.

NIRVANA QUARTZ

Having emerged from beneath a glacier in the Himalaya Mountains, Nirvana Quartz has one of the highest vibrations of spiritual love. Its ridges and etchings have been carved out by time and erosion of other minerals. The stone's soft pink color is transcendent and can help you have a breakthrough in understanding Divine, unconditional love, especially when the crystal is placed on an altar.

Sending Love

Use this ritual when you want to send love or heart healing to another person.

You'll need a heart chakra stone (see examples on page 31), a pen and paper, and an altar or dedicated space to place the crystal so it can be a focal piece.

1 Begin by choosing the heart chakra stone that you feel best connects with the person you have in mind. If you are having any trouble choosing, pass your receptive hand over your stones while visualizing this person and see if one feels right. You may experience this as a tingling sensation, a sign or cue, or a simple knowingness.

2 Write the name of the person that you wish to send love to on a piece of paper and place it underneath the crystal.

3 Put the stone on an altar or another sacred space.

4 Visualize the crystal creating a pulsation of love, sending it across time and space to that person.

5 Use this affirmation: "In pure intention, I send [person's name] the energy of true love."

Heart Activator

This ritual is perfect for those looking to meet someone, preparing for a first date, remembering how to love, or who need to turn their heart back on.

You will need one grounding stone (Garnet, Rhodonite, or Smoky Quartz), a heart chakra stone (Rose Quartz, Aventurine, or Nirvana Quartz are great), and two Quartz points.

1. Lying down on the floor (you can use a blanket or mat), place the grounding stone between your feet, the heart chakra stone on your heart center, and one Quartz point in either hand.

2. Imagine the stone between your feet is a seed of crystal energy. Close your eyes and imagine it opening. Feel Earth energy rise like a vine from the stone, up your legs, and into your heart center. At your heart, picture a lotus blossoming. Imagine that the stone lies right in the center of the flower.

3. Now imagine that it sends down two vines, one to each hand.

4. Open your eyes and feel this energy flowing in and out from the heart, filling you with the crystal frequency of love and light.

5. Breathe deeply in and out. You may chant the mantra, "Om mani padme hum," which is Sanskrit for, "Behold! The jewel in the heart of the lotus." Stay here for at least 7 minutes, or until you feel your heart completely restored.

6. .When you are ready, slowly remove the stones and come to a seated position.

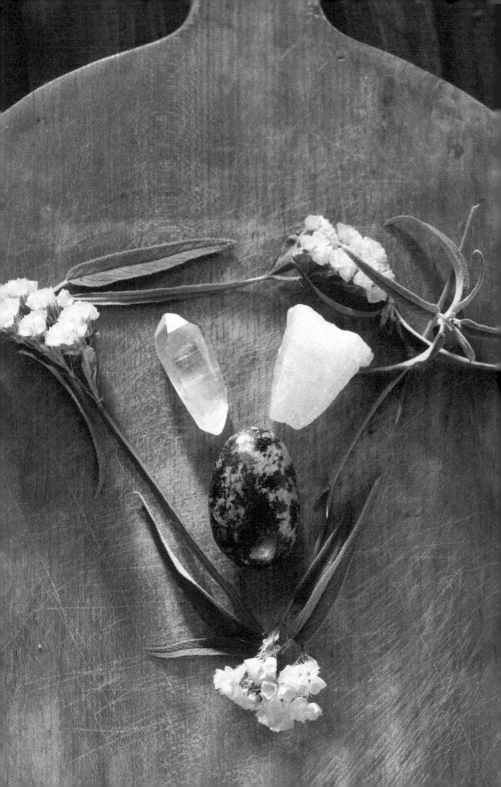

Letting Go

This ritual can be used to let go of heart heaviness, closed-heartedness, and any blocks or walls that need to be released. This ritual is most effective immediately following a Full Moon (within two days).

You'll need three heart chakra stones, one of which is also grounding. Find a space where you can place them on the ground before you or on a table if you'd prefer to sit in a chair.

1 Choose one grounding heart chakra stone (Rhodonite, Garnet, or Ruby Fuchsite) and two other heart chakra stones (Peridot, Rose Quartz, Calcite, and Rhodochrosite all work well, but you may use your personal favorites).

2 Place the three heart chakra stones in a downward pointing triangle shape before you. Place the grounding stone as the bottom point of the triangle.

3 Picture a pillar of light shining down from above through the center of the triangle, turning counterclockwise.

4 Breathe deeply into anything that is hurtful or heavy in your heart, and, as you exhale, send these things to the rotating light and let the stones pull this energy down and out. Imagine that these things sink into the earth.

5 Continue until you feel you have completely released. Allow the pillar of light to pause, and then begin turning in a clockwise direction.

6 See this light expanding, until the entire space around you is bathed in light and you are immersed in it.

7 Absorb the energy of love back into your heart.

Giving the Gift of Love

This ritual can be used when you are gifting a crystal to another person. By programming the crystal with an intention for that person, you are giving a much more powerful gift.

1. After selecting a stone that you wish to give to someone, prepare yourself by centering yourself in a calm position. Hold the stone in your receptive hand.

2. Close your eyes and take a few deep breaths. Visualize this person in your mind's eye.

3. Feel your crown chakra open and imagine light coming down from the Divine. Let this light carry the program that will be the most beneficial for this person. Remember, the program is not coming from your brain or will, but from Spirit.

4. Feel the light pour down into your crown and down to your heart center.

5. Hold the crystal up to your heart, and visualize your heart amplifying the program and directing it into the stone.

6. Place your other hand over your heart as well, sealing in the program.

7. Take a deep breath in, and, as you are ready, open your eyes. The stone is now ready to be gifted.

Dissolving Walls:
A Magical Bath Ritual

Sometimes we have walls built up from past trauma, toxic relationships, or other damage to the heart and emotional body. This ritual is used to dissolve those emotional barriers.

The best stones for this are Agate, Calcite, Moonstone, and Rose Quartz. The more the merrier. The best time for this ritual is during a Full Moon.

1. Begin by drawing a bath. Turn off the lights and light some candles.

2. You can add some herbs, like lavender, or flower petals, essential oils, and sea salt. Stir the bath in a clockwise direction.

3. Gently place your crystals on the floor of the tub as you state the following affirmation: "I charge this water with one hundred percent pure light and love and the power to dissolve and dilute any blockages or barriers in my emotional body."

4. Enter the bath and relax for a few minutes, taking some deep breaths.

5. Scoop water in your cupped hands and pour it over your head seven times.

6. State the following: "May the healing crystalline waters of light and love wash over me, and may I surrender my blocks to the Great Sea."

7. Lie back and locate your stones. Place them on your body—on your heart, your belly, and wherever feels right.

8. When you are finished, carefully get out and wrap yourself in a clean white towel or sheet. Dry off your stones and place them in the moonlight to recharge.

Attracting Love:
The Love Magnet Grid

Creating a love grid will help you magnetize all types of love to yourself as you broadcast it outward. This ritual is best done on a New Moon.

You will need seven different stones for this ritual. Choose one that will serve as the generator (see page 20). You can use any heart chakra crystals from the list in this chapter (see page 31). Clear Quartz points are also good. Make sure to include one grounding stone that contains a darker color, like Rhodonite, Hematite, or Obsidian.

1 Begin by getting centered and hold your generator up to your heart. Feel its energy expand around your heart center.

2 Take some deep breaths and send energy from your heart to the crystal in a figure eight.

3 Say out loud: "I program this crystal with the vibration of one hundred percent Divine Love. May it magnetize love toward me in equal measure to the love I give."

4 Place the generator on an altar or cleared area on a shelf or table.

5 Place the other six stones around it, with any points facing outward.

6 Light a pink or green seven-day candle and say, "As I light this candle, I ignite my intention."

7 Sit or stand in front of the grid as you think about your intention and take some deep breaths, picturing the aura of the grid growing and encompassing you. Place the intention in your heart. Feel your heart magnetizing and becoming open to receive.

8 After a few minutes, take a deep breath, exhale, and, placing your hands together, say a simple prayer of thanks.

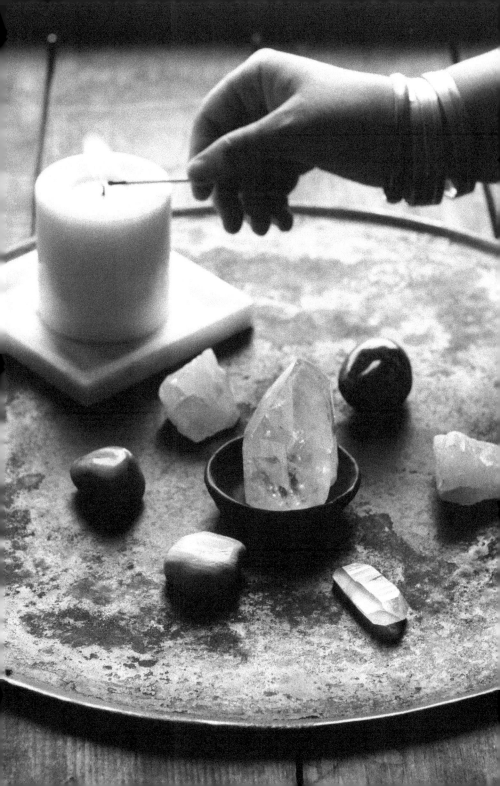

9 Keep your candle burning until it extinguishes itself. If you need to put it out, snuff it and relight as soon as you return. Spend some time with the grid each day to connect with it.

10 Once your candle is completely burned out, you may leave your grid set up for as long as you desire.

Love Potion #9

This ritual charges water, which you can then use for drinking, room sprays, and anointing. This infused water can elevate a space or your mood, and nourish you from within with the crystalline essence of love.

You'll need a glass bottle, a permanent marker, a small piece of Rose Quartz, a Moonstone, a Clear Quartz point, and drinking water.

1 On a clear night during a Full Moon, fill the glass bottle full of clean drinking water.

2 On the side of the bottle, on a label or with a permanent marker, draw the number nine, which is the magical number of the moon. Add any symbols you feel are appropriate.

3 Place a small piece of Rose Quartz, a Moonstone, and a Clear Quartz point into the bottle. (If your stones are too large to fit in the bottle, you can use a jar, or you can place the stones around the outside of the bottle.)

4 Place the bottle in the moonlight and say, "May this water be charged by the power of the Full Moon. May it be raised to its highest, most loving frequency. May it be imbued with the most loving energies of the crystal kingdom."

5 Leave the bottle in the moonlight overnight.

6 At sunrise, bring the water inside. Hold the bottle to your heart as you give thanks to the Moon Goddess and say, "I affirm this working complete. So it is."

7 Your water is now ready to use. You may drink it straight, or you may add a few drops to another glass or container of water. Its energy will not be diluted.

Note: Not all stones are safe to use in drinking water. Use only the crystals that are mentioned here. Be careful to not swallow your crystals!

Discover Your Heart's Desires

This ritual helps you look into your heart to discover your true feelings and yearnings when you find yourself confused or uncertain.

1 Choose a heart chakra stone (see examples on page 31) that has a groove or indentation in the side. On a polished or tumbled stone, this can be part of the shape. On a raw crystal this can occur when another crystal that grew with it was removed. This is called a keyhole.

2 Sit in a meditative state and hold the crystal in the hand it fits best, with the tip of your forefinger sitting in the groove of the stone.

3 Close your eyes and breathe deeply. Allow this crystal to serve as a window into the heart.

4 Imagine a line of energy flowing from the crystal into the tip of your finger. Visualize it running up your arm, past your shoulder, into your chest, and into your heart center.

5 Imagine the heart center being illuminated in the light of truth.

6 Within this light, visualize the image of any person, thing, or situation you want to explore.

7 Feel your heart and mind opening as you say, "Show me my truth."

8 Without second-guessing, notice how you instantly feel. This will reveal your true feelings about the situation.

9 Take a deep breath in, give thanks, and slowly open your eyes.

10 Smudge the crystal with sage or palo santo before using it again.

Opening to Self-Love

This ritual will help you love and appreciate yourself and build confidence in your ability to love others.

1 Use one of your heart chakra stones (see examples on page 31) that makes you feel the happiest.

2 Hold the crystal to your sacral chakra and say, "I am a creator of love." Remain here for a few minutes and repeat the statement three times.

3 Hold the crystal to your heart center and say, "Love flows through me." Repeat this statement three times.

4 Hold the crystal to your solar plexus and say, "I accept all parts of my being." Repeat this statement three times.

5 Hold the crystal once more to your heart center, take a deep breath, and say, "I honor and love myself." Repeat this statement three times.

6 Keep this stone with you throughout your day. When you need a boost of confidence, give it a squeeze.

The Purge: A Pattern Breaker

This ritual can be used to release obsession, codependency, and toxic relationships.

You will need five stones for this ritual. Choose a combination of Peridot, Rhodochrosite, Smoky Quartz, Clear Quartz, and Prehnite crystals. It is best to begin this ritual during a Full Moon and continue it for two weeks.

1 Begin with a clearing ritual for yourself and your stones: Use some sage to clear stagnant energy from your house, and smudge your crystals, too.

2 Place your stones on top of coarse sea salt in a small dish.

3 Center yourself, place your hands over the crystals, and state, "I charge this salt with the power to neutralize any unhealthy patterns or negative behaviors."

4 Leave your stones there overnight.

5 The next day, take the five stones, and lying down, place one at the bottom of each foot, one on your third eye, and one in each hand. Breathe deeply, close your eyes, and feel the stones drawing old, outdated patterns away from you.

6 Visualize the words, "*Let Go.*"

7 After 5 minutes, state, "I release all which doesn't serve me."

8 After another 5 minutes, take three deep breaths and come back into your body if you have drifted. Carefully remove the stones and sit back up. Drink some water. Place the stones back on the salt.

9 Repeat daily until the next New Moon. On the last day before the New Moon, throw the salt out in the street and say, "With harm to none."

10 Affirm the working complete.

Restoring Romance

This ritual can be used to kick-start a relationship that has run aground or lost its luster.

Use two high-frequency heart chakra stones like Nirvana Quartz, Pink Lemurian, or Kunzite. You will also need a small wooden box with a lid, a bowl of water, a cloth for drying, a past memento associated with your partner (a photo of a happy memory that you shared, a love letter that you saved, or a ticket stub from a movie or concert you attended, etc.), a pen and a few pieces of paper, and a length of ribbon. This ritual is best performed during the New Moon or during the waxing part of the cycle.

1 Begin, seated, with the box open before you and one crystal in each hand. Close your eyes, take a deep breath, and visualize your partner. If there is any resistance, anger, or negativity, gently breathe into the emotion and release it. Let the crystals help you.

2 When you feel ready, gently rinse the stones in water and dry them. Place them in your pocket as you fulfill the next few steps.

3 Into the open box, place your memento from the past.

4 On a piece of paper, write a few sentences about the first time you met. Put the place, the time of day, and any other details that stand out in your memory. Place this in the box.

5 Now take a few minutes to remember the moment that you realized that you loved this person. Recall the feeling. Write a few words down that convey how you felt and place the paper in the box. Allow this feeling to enter your heart center.

6 Take the crystals from your pocket. Imagine that one of them represents each of you. Place them in the box.

7 Imagine your future together. Take a moment to write down a few words or sentences about what you dream your relationship could be. Make it positive, vibrant, supportive, and passionate. Place the paper in the box.

8 Take a deep breath into your heart center, and hold it there for a moment. Imagine your breath as a vehicle for love and blow it into the box. Immediately close the lid and tie it shut with a ribbon.

9 Leave the box in a special place for the next seven days. Send it good energy, love, and light. On the seventh day, let your partner open it.

Building a Transmitter

This is a ritual that two people do together. It is intended to strengthen existing relationships between friends, family, or partners.

With both people present, you will need two crystal points and one heart chakra stone (see examples on page 31).

1. Begin by sitting comfortably across from each other in a meditative position. You may sit on the floor or across from each other at a small table.

2. Place the heart chakra stone an equal distance between you. This stone will serve as the generator (see page 20).

3. Place the crystal points a few inches away from the generator, with the points facing toward each person.

4. Inhale together as you both imagine your crown chakras opening and a beam of light descending into you.

5. Exhale and allow this light to pass through you and anchor into the core of the earth.

6. Inhale and bring the light back up into your heart chakra.

7. Visualize this beam of light shining outward from your heart, through the crystal transmitter and to the other person. Using your breath, allow this light to move in a figure eight.

8. Send healing back and forth between your heart centers. The figure eight honors the free will of each person. Let it flow, give, and receive. The stones will fortify and amplify the bond between you.

9. When you have finished, take a deep breath in and out and close the ritual.

7 One-Step Heart Healers

These simple steps can be done separately or together to mend a broken heart. You can use these simple rituals whenever you need them.

Use your favorite heart chakra stones (see page 31 for examples).

1 Hold a crystal on your chest, with the point facing down if it has one. Slowly breathe in and out. Visualize the crystal directing pain down and out as it draws light in from above.

2 Place a stone under your pillow, allow it to assist you while you sleep. Let any restlessness flow down as loving energy supports you.

3 Wear a crystal on a chain around your neck or tucked against your skin. Keeping it close to your heart will help when you are out and about. Let it be a loving companion.

4 Take a crystal to a body of water. After holding it to your heart to absorb all of your heartache, lovingly throw it into the water as an offering.

5 Keep a crystal in your pocket. Whenever you begin to feel sad or anxious, hold the stone in your receptive hand and breathe in and out gently. Let it bring you back to yourself.

6 Take a crystal with you out into nature. Find a place to "plant it." This symbolic letting go can lead to growth and something new.

7 Make mini altars around the house. Place your favorite love crystals in view with your other stones around them. Place them in special spots where you'll notice them each day, thus surrounding yourself with unconditional love and support for heart healing.

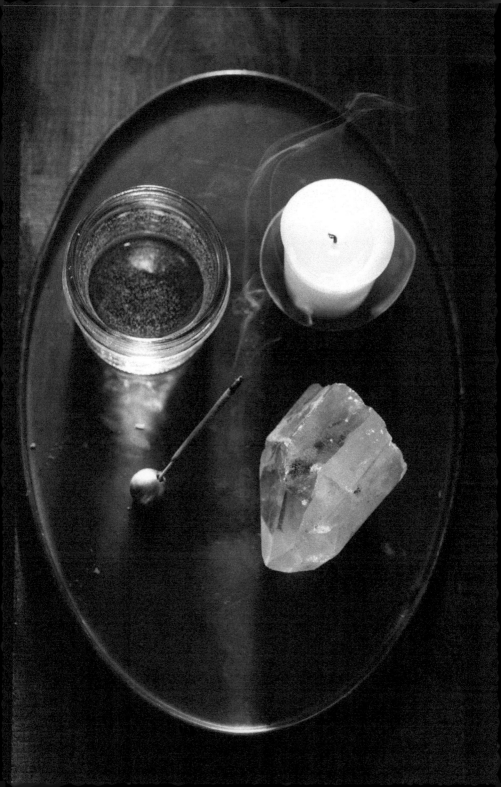

Creating a Love Altar

By incorporating all five elements, a love altar creates a powerful vortex that can fill your home with the energy of Divine Love and serve as a focus for your intentional meditation.

You'll need a glass or goblet of water, floral incense (cones or sticks), a white, red, or pink candle, and a heart chakra crystal of your choosing (see page 31 for examples).

1 Find a place in your home where you can create this altar. (You don't need a lot of space.)

2 Place the items in the following arrangement:

 ▪ Candle in the back right corner
 ▪ Water in the back left corner
 ▪ Incense in the front left corner
 ▪ Crystal in the front right corner

3 Light your candle and incense, and say the following prayer: "Fire, Water, Air, and Earth, the magical elements, the tools of creation. May I establish the energies of one hundred percent Divine Love within and about me, above me, and below me. May Spirit connect them all. So it is."

Radiating Love

This ritual helps expand your vibration of unconditional love as you work from the inside out. With daily practice it grows stronger in time. Begin with steps 1 through 3, and when you feel ready, proceed to step 4, adding another concentric circle.

The best heart chakra stones to use for this are Pink Lemurian Quartz, Rose Quartz, and Kunzite.

1 Sitting in a meditative state, place one crystal in the open palm of each hand. If they have points, face one outward on your projective hand, and one inward on your receptive hand. Otherwise, just hold them in whatever way they fit best in your palms.

2 Relax and become receptive, feeling energy flow out of one hand, around your body, and in through the other. Picture this as the energy of pure love and let it circulate around you.

3 State the following affirmation: "I am a being of one hundred percent Divine, unconditional Love."

4 Let this energy move for a few minutes, until you feel completely filled with this frequency.

5 Allow the energy to begin to spiral outward, creating a concentric ring around you. Within this ring, visualize your closest loved ones. Say: "I radiate love to those who are closest to my heart."

6 Let the spiral create a larger ring around you. Within it, visualize your larger community. Say: "I radiate love to all who come into contact with me."

7 The spiral can now expand larger, until it is the size of the entire planet. Say: "I radiate love outward to all beings upon the earth."

As you practice this ritual, your heart chakra will be more open and uplifted. The results will be personal at first, but it starts with self-love and expands outward, like ripples upon water, into the world.

Love Through the Gateway of Nature

Feeling at one with nature allows you to connect to the unconditional love that Mother Nature has for all her children. This ritual is restorative for all of the subtle bodies and helps you to feel a deeper love for this planet we call home.

Take your crystals with you on a hike, to a park, or anywhere in nature where you can find some quiet space to sit and commune with the nature kingdom.

1. Place your crystals around you on the ground in a grid formation. You can use your own intuition here; there is no right or wrong placement. You may also hold one in the upright palm of each hand.

2. Close your eyes and let yourself breathe in and out, clearing the mind and heart. Call upon the Earth Goddesses: Gaia, Demeter, Ishtar, the Empress, and Mother Nature herself.

3. When you feel ready, begin to chant the crystal healing mantra, "Om Mani Padme Hum." This means, "Behold! The jewel in the heart of the lotus." (Traditionally, mantras are chanted 108 times. If you have a mala or rosary, you can use it to keep track by counting beads, but I recommend that you simply continue chanting until you have completely lost yourself in the mantra and are no longer aware of any worries, distractions, pain, or problems.)

4 When you feel ready, slowly return to deep breaths and let yourself sit in complete silence, gradually taking in the sounds of nature around you. You may want to lie down at this point. If you do, this is a good time to go into the next ritual, or you can close your ritual here with an expression of gratitude.

The Hexagram of Anahata

The hexagram is a symbol of the heart chakra, which is called *anahata* in Sanskrit. Use this ritual when you want to create a talisman that will be charged for love and heart-centeredness. You can then carry this talisman with you whenever it is important for you to come from this place. When you are not using it, keep it on an altar.

For this ritual you will need seven crystals. They do not need to be heart stones specifically, but the main crystal should be a heart stone (see page 31 for examples). Rose Quartz is a perfect choice.

You'll also need a space about 12-by-12-inches big to set up this crystal grid.

1 With three of your stones, make an upward-pointing triangle. This represents your desire to reach upward toward the source of Divine Light and Love and the connection to Divine Unity that you seek.

2 Overlay this with three more stones that create a downward-pointing triangle. This represents Spirit's descent into matter. It is the emanation from Divine Source down into manifestation: the downpouring of energy from the highest vibration into the final product on the material plane.

3 In the center of the crystal grid you've created, place your final heart chakra crystal. This is the one that will become the talisman. See it as contained within these energies from above and below and let it be charged with both.

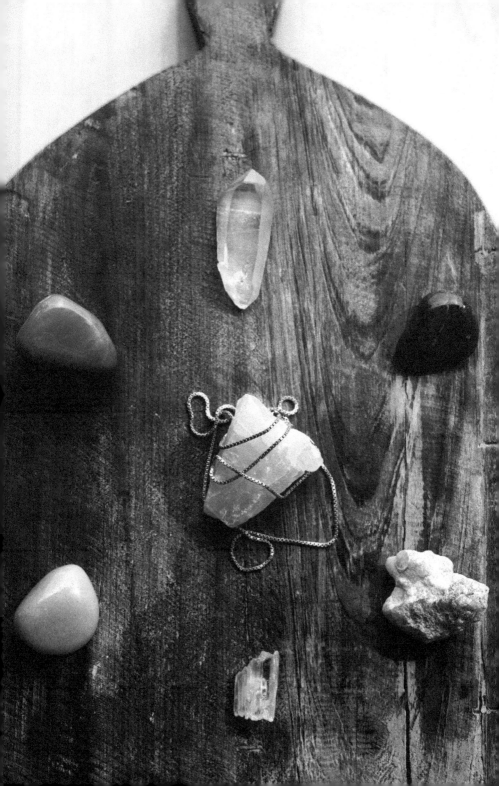

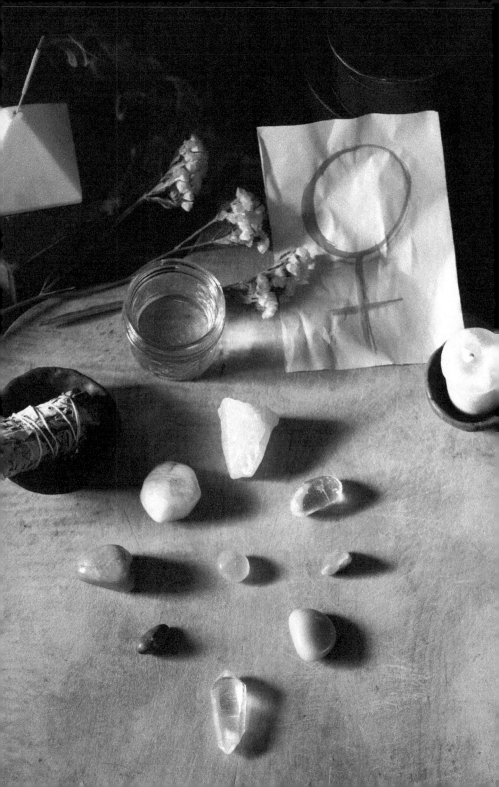

4 You can leave the center stone there, or you can take it with you throughout your day, meditate with it, sleep with it, or even gift it to a loved one.

5 You can also place other items you want to charge with this energy inside the hexagram, including names, photos, jewelry, trinkets, magical tools, and anything you'd like to imbue with heart-centeredness.

Invocation of Venus

As the Roman goddess of Love, Venus has long been heralded as a deity to invoke for assistance in love, romance, and fertility. Use this ritual to call upon the Goddess Venus for her Divine assistance. This will be very useful for your personal meditation.

You'll want to perform this ritual on a Friday, which is the day assigned to the Planet of Venus.

You will need eight crystals in an assortment of pink, green, and white or clear. Any of the heart chakra stones (see page 31 for examples) will do, or any others that you have that fall in this color spectrum.

You'll also need sage for smudging, an appropriate incense (such as rose, geranium, or jasmine), a green candle, a goblet of water, flowers (if you have them), paper, and a pen to draw the symbol for Venus (or you can print one out). Make sure the symbol is at least six inches tall.

1 Begin by taking a bath to clear your energies, then dressing in clean clothes and smudging yourself.

2 Place the piece of paper with the Venus symbol on it on a table or altar. Place the goblet on the left side and the candle on the right side of the symbol. Place the incense on a burner in the back.

3 Set up your crystals on the symbol in the following way: Four on the outer edges of the circle, one on the end of each arm of the cross, and one in the center of the cross.

4 If you are using flowers, place them around the grid.

5 Light the incense. Light the candle and say, "I call upon Venus, Goddess of Love, Fertility, and Divine Beauty. Show me a sign and help me radiate these same qualities. Help me broadcast the frequency of love, and show me what it means to live in a more loving way. Teach me to love myself unconditionally and to attract unconditional love. I center myself in gratitude for these blessings. So it is."

6 Spend some time in meditation and bask in the glow of what you have created.

Full-Body Love

Use this ritual to attune your entire body to the vibration of love. This is a deep-healing ritual for the emotional and etheric bodies, running healing crystal energy through all layers and levels.

You'll want to use one grounding stone (see page 69 for examples), and at least six other crystals. Rhodochrosite, Clear Quartz, and Moonstone are all good choices. At least three of the remaining stones should resonate with the heart chakra.

1. Sit with your legs stretched out before you on a mat or blanket. Place your grounding stone between your feet. If the crystal has a point, face it away from you.

2. Lie down with your crystals within reach at your sides. Place one stone on your sacral chakra (Rhodochrosite works great here, or any sacral stone), one lying on the ground above your crown (a Clear Quartz point facing toward you), and one on your third eye (you can use Moonstone here or any third-eye crystal).

3. With your last three stones—the love stones—place one on your heart and hold one in the open palm of each hand.

4. Allow yourself to relax, and let your body be the conduit for all of the crystals to connect to one another. Imagine light connecting from each point to the other, and feel the vibration of crystal love healing run though your body.

5. Allow yourself to go into deep meditation, and spend 20 minutes with the stones in place.

6. When you are ready to come out of the meditation, slowly move your hands and feet and remove the crystals from your third eye, heart, and sacral chakras.

7. Slowly and carefully sit up and gather the stones from above your crown and between your feet.

8. Take some time before rushing to the next part of your day. Make sure to drink plenty of water.

9. Clean your stones before using them for anything else.

Heart Chakra Initiation

An initiation is the first step of a new cycle. Whether starting a new relationship, preparing yourself for dating, or getting ready to take your current partnership to the next level, you can perform this ritual.

With your love crystals (see page 31 for examples) in your hands, get yourself into a comfortable position for meditation. For this ritual, lying down usually works best.

1 Take three deep breaths and call upon the Devas of the crystals (see page 12). Call upon your highest guides.

2 See if you can feel the presence of your guides. Once you do, allow yourself to have the following visualization. If you would like, you can have someone else read it to you from this book.

A warm rose-colored glow builds at your hands, and you feel a pink ray begin to run up each arm. This is the crystal pink healing ray.

As it moves up your arms, it crosses your shoulders and moves into your chest. These two beams meet in your heart and fill your heart center with soft pink light.

Within your awareness, visualize your own interior temple. This is your inner sacred space. The temple is filled with this same pink light. It radiates from an altar in the west.

The windows above the altar are open and a gentle breeze blows through.

The chalice upon the altar overflows with purifying, nourishing essence of Divine Love and Light.

As the light in your heart center builds, you now feel it begin to flow outward from your heart, through your veins, spreading outward to touch and flow through all parts of your body. It moves down your legs to your fingers and toes, and flows back again.

As you breathe, allow this healing pink light to flow throughout every layer and into every molecule of your being.

Allow this light to expand beyond your physical body and to fill your astral body, expanding out a foot in every direction from the surface of your skin and circulating in all directions.

After a moment, return your focus to your heart center. Send a beam of light to any person, place, thing, or situation in need of healing at this time.

Bring your attention back to your heart center. Your heart is now completely restored in incorruptible gold.

3 Affirm to yourself, "I am a being of one hundred percent Divine Love. So it is."

4 Take a few deep breaths as you pull your conscious awareness back into your body. Slowly begin to move, and when you are ready, sit up carefully.

5 Pause for a few moments in an expression of humble gratitude, quiet and still.

Wealth, abundance, strength of purpose, and a fulfilling career: These are things that most people want in life. The trick to achieving them is being in the right mind-set, working hard, and aligning with the frequencies of prosperity and success. The rituals in this chapter will show you how to reach this alignment.

CHAPTER 3

Money

RITUALS FOR WEALTH, CAREER, AND ABUNDANCE

THESE ELEMENTS OF THE SELF ARE CENTERED within the solar plexus chakra—the core of your being—located at the base of your sternum right below your rib cage. Just like the Sun is the center of the solar system, your solar plexus is the center of your personality and ego. It is here that you find your interior compass and can direct your actions productively.

Having a healthy solar plexus means being clear on your values and priorities. It is the center for your integrity, your self-respect, and your belief in yourself. When these qualities are brought to the foreground, your ability to create the kind of life that you dream of becomes possible. When you can confidently shine your values into the world, it becomes apparent to the people around you, and, in turn, you attract what you need to fulfill your goals.

Working with crystals that resonate with the solar plexus can awaken your true potential. They help clear out the frequencies of doubt, fear, self-loathing, and laziness. Solar plexus stones can then awaken motivation, drive, and ambition, as these are aspects of a healthy ego. A balanced core also ensures that your goals are centered in righteousness and integrity rather than coming from a place of greed or misplaced cravings for power. The real key to maintaining prosperity and fulfillment is gratitude.

Some of the rituals in this chapter will help heal imbalances in the solar plexus so that you can reestablish a healthy core. Many of the stones that you will use in these rituals are extractive stones that fall within the yellow color spectrum. Once blocks are released and balance is restored, you can move on to the rituals that use amplifying stones to assist with growth and forward movement and enhance the manifestation of your goals. Green is the color of growth, and green crystals can assist you in becoming abundant and fruitful. Grounding stones can help you keep your head on straight and anchor you in your progress and plan for the future.

TIGER'S EYE

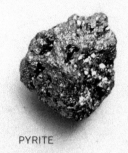

PYRITE

EMERALD

CARNELIAN

GREEN AVENTURINE

TOP SOLAR PLEXUS CRYSTALS FOR WEALTH AND ABUNDANCE

TIGER'S EYE

Able to work on all chakras at once, Tiger's Eye is a stone that strengthens your sense of individuality and assists you in evolving. It is a transformative stone that can help you become a better version of yourself while staying true to who you are.

CARNELIAN

This red, orange, and milk-white form of banded Chalcedony is a perfect stone for amplifying your energy levels. Carry it with you when you need an extra dose of motivation. You can also place it on your sacral chakra to get your creativity flowing.

PYRITE

Also known as Fool's Gold, Pyrite is a fiery stone of magnetism. It not only helps draw forward the right resources and attract what is needed, but it also deflects the things that are not necessary so they don't become distractions.

GREEN AVENTURINE

In its green variety, Aventurine is a stone associated with luck, prosperity, and growing wealth. It is an energizing stone that can bring vitality to your endeavors, and when carried throughout the day, it can help you maintain a positive outlook.

EMERALD

A gemstone of Venus, Emerald has a long association with both wealth and fertility and aligns with the energies of springtime, when the earth comes back to life and brings forth blossoms. Wear Emerald when you wish to breathe new life back into old dreams.

KAMBABA JASPER

Also known as Crocodile Jasper, Kambaba Jasper helps anchor your progress so that what you earn can be held on to. If you feel as though money is slipping through your fingers, a grounding green Jasper can help things stick around.

SUNSTONE

Shimmering with flecks of copper, Sunstone can be useful in maintaining an optimistic attitude. Holding Sunstone to the solar plexus can be helpful when weighing options and making important decisions. The frequency of this crystal helps make your options clearer. It can also assist in setting goals for the future.

MALACHITE

Forming layer upon layer as a stalactite, the green bands of Malachite demonstrate growth on top of a solid foundation, making it one of the best stones to work with when you want to maintain steady growth over a long period of time.

YELLOW CALCITE

A gentle extracting stone for clearing blocks to abundance, Yellow or Golden/Honey Calcite can be used to release any blocks in the solar plexus by holding your stone up to this area and breathing deeply for a few minutes. Rinse it with cool water when finished.

CITRINE

Known as the crystal of manifestation, and also called the Merchant's Stone, Citrine is one of the most potent crystals of the golden rays of the Sun, and it is one of the most powerful activators of the solar plexus. Keeping it close can help bring your goals to life and manifest results.

KAMBABA JASPER

SUNSTONE

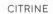

CITRINE

MALACHITE

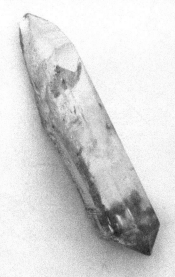

YELLOW CALCITE

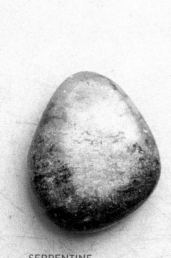

MOSS AGATE

SERPENTINE

GREEN TOURMALINE

YELLOW APATITE

YELLOW FLUORITE

MOSS AGATE

While it may just look like a green stone at first, holding Moss Agate up to a light reveals that it contains a tiny terrarium. Mimicking nature, it appears to have moss or plant matter growing inside of it. (It is actually green minerals within Clear or Milky Quartz.) Keep Moss Agate with you when you want to grow your business, your network, or your bankroll.

SERPENTINE

The path of success is not a straight line; it curves and bends, rises and falls. Sometimes people need assistance over hurdles or around blocks. Serpentine teaches the way of flow and flexibility, finding ways around obstacles when charging straight ahead is not an option.

GREEN TOURMALINE

With a very high vibration, Green Tourmaline is an activator for magnetism and growth. This stone can help keep away negative energy as well as take your goals higher than you might have ever expected. straight ahead is not an option.

YELLOW APATITE

Fulfillment and success mean different things to everyone and are influenced by each person's gifts and talents. Yellow Apatite assists by bringing your gifts to the surface and shining your unique values into the world, thereby drawing things toward you that reflect those values.

YELLOW FLUORITE

Fluorite is one of the best stones for focus and organization. When you want to be very direct in what you are putting forth into the world, this is a good stone to work with to hit your target.

Doors of Opportunity

This ritual helps bring in the energy of prosperity every time you open your door.

You will need a small cloth bag (one made of cotton or silk works well) and 11 assorted coins. (You may use coins from other countries if you wish.) To make this ritual especially potent, choose coins that have a year that add up to the number six, which is the number of the Sun and of balance (for example: 1986, 1995, 2004, 2013).

For your crystals, small pieces of Aventurine, Malachite, Citrine, and Emerald are all good choices. You can also use Clear Quartz to amplify their properties.

1 Wash the coins and dry them. Then smudge with some sage.

2 Place your crystals in the sun for 30 minutes to charge them.

3 Place the coins and the stones inside the cloth bag.

4 On the inside of a door that opens inward, tie the bag to the doorknob.

5 Every time you open the door, you'll hear the sound of the coins and crystals jingle. Consciously acknowledge this and say to yourself, "I open the door to prosperity and welcome it in."

6 On the last day of each month, take the coins and stones out to recharge on your altar or in the sun for a day. Then return them to the bag and reaffirm your intentions.

Divine Realign

Use this ritual when you want to change your luck, break patterns and mind-sets that block abundance, and realign with a new attitude and outlook. The best time to perform this ritual is on the first of the month.

For this ritual you will need an extractive stone, like Yellow Calcite or Yellow Fluorite, and an amplifying stone, like Sunstone or Citrine.

1 Before going to bed, look up what time the sun rises where you live and set your alarm to get up at sunrise.

2 Place your amplifying stone on an altar or charging grid (see page 109) overnight.

3 Place your extractive stone under your pillow. Allow it to work on your subconscious while you sleep, drawing out mental blocks.

4 Before falling asleep, say the following affirmation: "May I release any unhealthy, stuck, stagnant, or negative patterns that block my ability to manifest abundance. May I create space for a new day and a new way."

5 At sunrise, take the stone out from under your pillow and rinse it off. Then place it on your altar or grid to charge. Take the other stone that you charged and find a place where you can sit and face the horizon to watch the sunrise.

6 Hold the stone to your solar plexus. Breathe in deeply.

7 Imagine the energy of the rising Sun moving into your solar center, expanding outward along your energetic meridians, strengthening you from the inside out, and guiding you to new ways of being.

8 State the following: "I am ready to allow my will to be aligned with the Divine Will."

9 Stay in this meditation for at least 10 minutes. You may carry this stone around with you for the rest of the day to stay mindful of the work.

Gratitude Altar

One of the best ways to welcome blessings of abundance is to center yourself in gratitude. The best time to do this ritual is during a Full Moon. You'll add each of the elements: Fire, Earth, Air, and Water in their zodiacal order.

You can use any of your favorite solar plexus stones. You will also need a yellow or gold candle, a pen and piece of paper, and fresh flowers.

1 Find a place in the center of your home to create your altar. Make sure there is no clutter in the surrounding area.

2 Fire: Place the candle in the center.

3 Earth: Place your stones around the candle. If they have points, point them outward.

4 Light the candle and say, "As I light this candle, I illuminate all of the blessings that I have to be thankful for."

5 Air: On the paper, write a thank-you letter to the universe. List the things that you are grateful for. Place the letter under the candle.

6 Water: Place flowers around the candle as an offering to Spirit.

7 Feel this energy radiating outward and filling your entire home.

8 Keep this altar set up until your candle burns all the way out. If you
 need to put it out, snuff it and relight as soon as you return.

Make a Money Tree

Money may not grow on trees, but plants do represent growth and fruit-fulness. You can incorporate them into this ritual to support growth in your business, projects, investments, and resources.

Good stones to include are Serpentine, Kambaba Jasper, and Moss Agate. This ritual is best begun at the start of spring.

1 Begin by choosing a healthy houseplant. This can be a plant
 you already have, or you can purchase a new one or grow one
 from seed.

2 Place your crystals around the base of your plant. You can press
 them lightly into the soil, but they should not touch the plant itself.

3 Make sure this plant gets plenty of sunlight. Water it regularly. You
 can also put a piece of Citrine or Green Aventurine in your watering
 can to charge the water with the energies of manifestation.

4 Make sure to always remove any dead leaves immediately.

5 Acknowledge this plant as a teacher that can help you understand
 more deeply what it means to grow and thrive.

6 If you ever have a crystal that breaks, you can also add it to your
 money tree. Plants do not care that crystals are broken or imper-fect. They are valuable minerals of the earth that still resonate with
 the same vibration, regardless of any chip or crack.

Planted Wealth Boosters

Select the stones listed for the scenario(s) you'd like help with. Then take each one through this ritual. These crystals can assist in attracting wealth.

1 Begin by holding the stone in your receptive hand. Take a deep breath and enter a meditative state.

2 Allow yourself to receive the energetic resonance of the stone. Let it rise up your arm, into your heart center, and down to your solar plexus.

3 Send energy back down to the stone from your core and allow this energy exchange to cycle for a few minutes. While you do this, make an agreement with the stone: "I affirm that this work is done in alignment with the highest good, for the purposes of beneficial prosperity, that I may better be of service to myself and others."

4 You'll now program your crystal. Switch it to your dominant hand and say the following: "I program this crystal with the frequencies of wealth and prosperity. I program this crystal to be self-cleansing and to keep the area around it free from negativity. I program this crystal to radiate these frequencies to the best of its ability and for the greatest good. So it is."

5 Now place the crystal in the appropriate location:

- Citrine: In your wallet
- Ruby or Emerald: In your cash register
- Pyrite: In your tip jar
- Moss Agate: In your piggy bank, or another container that symbolizes saving money for you

The Right Tool for the Job

When you are working toward a goal, sometimes it can be hard to know which angle to approach it from. In this ritual, you use crystals for divination, direction, and inspiration.

You will need a cloth bag (big enough to reach into but not see into) and six crystals, each of which you will assign a certain directive. I've provided a list of suggestions below, but you may use other stones or change the wording to fit your needs.

Green Aventurine: "Please guide me in asking for help when needed and trusting the advice I receive."

Pyrite: "Assist me in staying motivated, and help me be a motivating influence for others."

Citrine: "Help me push forward through obstacles, over hurdles, and around blocks."

Kambaba Jasper: "Please grant me the patience to stay the course and let things develop in their proper time."

Sunstone: "Give me the courage to shine my light into the world and share my talents and ideas."

Yellow Calcite: "Help me be a good listener, and help me pay attention to the important signs around me."

1 Clear your crystals and give them a good charge by placing them in the sun for half an hour.

2 Spend a few minutes with each one individually. Hold it in your receptive hand and repeat the associated words a few times as you visualize yourself behaving in that specific way.

3 Once you have sat with each of the stones and visualized all six behaviors, place the stones in your bag.

4 Place the bag on your altar or on a charging grid (see page 109).

5 Starting the next morning, hold the bag, center yourself, take a deep breath, and visualize your current goals.

6 Make this statement: "I call upon my highest guides to help me know the right way to proceed."

7 Draw one stone out. That is the attitude for you to use throughout your day. Carry it in your pocket as a reminder.

8 At the end of the day, place the stone back in your bag, recharge the bag on your altar or grid overnight, and repeat the process the following day.

9 Repeat for seven days. Each day record your results. Taking time to recognize what was effective can teach you a lot about yourself. Remember to center yourself in gratitude for your positive outcomes.

Making It Stick

It is one thing to attract abundance but another thing to make sure wealth doesn't slip through your fingers and disappear as quickly as it came. This is a grounding ritual so that those things in which you've invested time, energy, or money endure.

The best stone to use for this ritual is Kambaba Jasper, or any other form of Green or Yellow Jasper. You'll clear and charge your crystal with Earth energy (see page 8), so you will need coarse sea salt and loose herbs, such as rosemary, red clover, or sweetgrass. Herbs that you gather yourself can be even more powerful.

1. Place some coarse sea salt in a small dish. Place your stone on top of the salt and let it sit there overnight so the salt will draw off and neutralize any low vibrational energies.

2. The following day, throw the salt out, preferably off your property, as you say, "With harm to none."

3. In the same dish, you'll now make your crystal a bed of herbs. Place just enough loose herbs for your stone to nestle in nicely. Place the crystal there overnight to charge and soak up healing Earth energy. You can reuse these herbs to continue to charge this stone.

4. With your stone now cleared and charged, you can place it wherever you need to anchor in your progress. For instance:

 ▪ Carry it to a job interview. When you get home, place it on top of your interviewer's business card or another representation of the company.
 ▪ Keep it with you when you are working on a project, as a reminder to see things through.
 ▪ When you receive money for work you have done, take a small percentage (it can be as little as a dollar) and place it underneath this stone. Let it accumulate and serve as inspiration to keep income flowing in.

Prosperity Magnet

This ritual maximizes the energies of the earth, magnetic currents, and ley lines to create a powerful magnet for abundance.

Use any and all green crystals here. Stones that are cut into obelisks, generators (see page 20), and towers are especially powerful and magnetic.

You will also need a green candle, a small bell, coins (and paper money, if you have it), and any personal symbols of prosperity and good fortune.

1 Locate the southeast corner of your home or office. This is the direction that is associated with prosperity. If that part of your home is not accessible or appropriate, you can use the southeast corner of an individual room as well.

2 Remove any clutter and clean the space. Use some sage or palo santo to lift the energy, as negative energy can sometimes get trapped in corners. Make sure to open any windows or doors while you do it.

3 Place the candle on top of the paper money and place any coins around it. Place your green crystals around the candle and money. If you have one larger crystal, place it in the front. Make sure any points are facing outward.

4 Place the rest of your good fortune symbols around the candle, and your bell. Ring your bell to awaken your crystals.

5 Light your candle while saying the following: "As I ignite this candle, I light roads to good fortune, success, and prosperity. May I magnetically attract the right resources, people, and opportunities, and may I receive these blessings with grace and gratitude. May I be generous, and may I use the fruits of this work to bring greater good to the world. So it is."

6 Take a moment every day to acknowledge and reaffirm your intention. Make sure to keep this area free of dust or any misplaced items. You may leave this set up for as long as you wish, or at least for one Moon cycle (28 days).

Motivation and Productivity

Use this ritual when you need to ramp up your energy levels and get motivated.

You will need a piece of Carnelian and a piece of Citrine. The best time to perform this ritual is during the Waxing Moon cycle, between the New Moon and the next Full Moon.

1 Perform this ritual 10 minutes before the start of your workday or before working on your current project.

2 Sit in a meditative position (see page 15), take a few deep breaths in and out, and center yourself in the present moment.

3 Hold your Citrine to your solar plexus and hold your Carnelian to your sacral chakra.

4 Visualize a spark of light centered at each of your crystals.

5 While breathing, imagine this light traveling back and forth between the crystals, in a figure eight. As you inhale, draw the light up from the Carnelian to the Citrine, and, as you exhale, complete the figure eight as you imagine the light descending.

6 With each inhale, feel energizing life force strengthening your core and moving outward through the meridians of your body.

7 Affirm to yourself, "I am centered; I am capable; I am ready for the day. May I put my best foot forward, may I use my time wisely, and may I channel my energy toward productive results."

8 Visualize yourself having already accomplished your goals, and from the present moment, allow yourself to see the shortest path to the finish line.

9 After 10 minutes, take one final deep breath into your solar plexus and begin your work. You can keep the stones with you in your pocket as reminders to stay on track.

Removing Roadblocks

When we fear success or potential, our inner saboteur can be our own worst enemy. Use this ritual to release fear and self-sabotage and reestablish your self-worth and confidence.

You will need four solar plexus stones for this ritual. Citrine, Yellow Calcite, Pyrite, and Yellow Apatite are all good choices. You will also need matches, a heat-resistant bowl, a small piece of paper (a quarter page works well), and something to write with.

1 Find a place outside where you can sit comfortably on the ground. Take a few minutes to center yourself and lay your tools out before you. Take a few deep breaths, close your eyes, and listen to your interior dialogue.

2 On the piece of paper, write all of the words or statements that block your self-worth. Write anything that makes you feel less than. You can include any insult that has been thrown at you, or any name you have been called. Write down any negative word that you have used to describe yourself.

3 Fold the paper in half and place one of your stones on top of it.

4 Place one stone behind you and say, "My past does not define me." Place one stone to your left and say, "No assumptions made about me may hold me back." Place one stone to your right and say, "My present does not limit me."

5 Remove the fourth stone from the paper and place it in front of you. Say, "My past has only made me stronger. May others bear witness to my evolution. My present is the first step toward my greater success. I now open the path to my potential."

6 Take the piece of paper and begin to tear it into pieces. With every rip, feel yourself detach from the things you wrote down. Place the pieces in the bowl.

7 Light the paper with the matches and burn it all the way down to ash. As you do this, say, "I affirm that I release self-doubt, insecurity, fear, and blaming. I banish false pride, envy, and jealousy. I clear away weakness, instability, and indecision. I release myself from the bondage of my own self-judgment and harsh self-criticism. I release the little voice inside my head that says I am not good enough, that I am undeserving. This voice is not my truth. I send it to the light. So it is!"

8 Feel the four stones around you creating a protective grid. Draw this energy into your core and let it run through you.

9 When you are finished, close the ritual with gratitude, return the stones to your altar to charge, and dispose of the ashes.

Shine the Lantern

Use this ritual when you want to attract resources, be visible to others for networking and assistance, and draw attention to your values, accomplishments, and abilities.

You will need Sunstone, Pyrite, Yellow Fluorite, or your favorite solar plexus crystal.

1 Hold your crystal in your receptive hand. With the index finger of your dominant hand, trace a hexagram in the air over your stone, imprinting it with the six-rayed star.

2 Lie down on your back with your feet a few inches apart and your arms by your sides.

3 Place your stone on your solar plexus. If it has a point, make sure it is facing toward your feet.

4 Close your eyes and send your awareness to the center of your body. Imagine the stone igniting a spark of light in your core, like a lantern shining within you.

5 Each time you inhale, visualize the glow of the lantern increasing. See it shining outward in six directions. Focus on each individual beam of light:

- One beam shines before you, to illuminate your path.
- One beam shines behind you, to help you understand your past.
- One beam shines to your right hand, to guide your actions.
- One beam shines to your left hand, to attract your allies.
- One beam shines above you, to keep you connected to the Source.
- One beam shines below you, to keep you connected to Earth.

6 After you have visualized each of these six beams, focus on their intersection and say, "May I attract that which is useful, balanced, and mutually beneficial, and reflect away what is not. May this light be visible to those I may help and to those who may help me. May I always find my way back to my center. So it is!"

7 Take a deep breath in and, as you are ready, open your eyes, remove your crystal, and gradually return to a seated position.

8 End with gratitude and affirm the work complete.

Workplace Harmony and Teamwork

Placing a programmed crystal in your office or workplace can greatly increase the positive energy of that environment. Clusters of crystals are helpful when multiple people are working together on a project. They also help clear the energy of a space. You can use a Clear Quartz, Citrine, Smoky Quartz, or Amethyst cluster.

1 Clear your cluster with some sage and sunlight.

2 Place it on your altar or charging grid (see page 20). Hold a visualization of everyone at your workplace operating in harmony, and project this vision toward your crystal.

3 Set it with a program by placing your hand over it and say the following: "I program this crystal with the energy of cohesive cooperation and communication. May we have open channels of respect and healthy support. So it is."

4 Take the stone to your workplace and situate your crystal as much in your field of vision as your circumstances allow.

Self-Worth Booster

This ritual will help you amplify your self-worth, your drive, and your magnetism by attuning your solar plexus.

You will need any solar plexus stone. Good choices are Citrine, Sunstone, and Serpentine. You will also need one Clear Quartz point.

1. Sit in a meditative position and take a few deep breaths to center yourself.

2. Hold your Quartz point in your dominant hand, facing away from you.

3. Hold the solar plexus stone in your receptive hand.

4. With an open heart, take a deep breath in and visualize light traveling from the stone in your receptive hand, up your arm, and into your heart chakra. As you exhale, allow the light to expand outward, filling your entire chest.

5. On your next inhale, draw the energy down to your solar plexus, and point your crystal point directly at this part of your body. As you exhale, allow the light to expand outward from this center. Stay in this expansion for the next few breaths.

6. After you feel this area grow warm and become open, send some energy from your core back up to your shoulders, and then back down your arm to your crystal. Allow golden light energy to flow freely back and forth, and to move throughout the rest of your body to your opposite arm, down your legs, and up to your head. Allow yourself to be bathed in the golden glow. Feel yourself attuned to the crystal's purpose and life force.

7 Affirm to yourself, "I am a being of light. I am a being of purpose and strength. I am a being of courage and conviction."

8 Take a few more breaths and, when you are ready, set down your stones and close the ritual.

Talisman of Wealth

Charging a stone as a talisman is one way to draw the energy of wealth toward you. This talisman can also be helpful for curbing unnecessary spending.

Malachite, Tiger's Eye, and Emerald make good talismans. Begin this ritual on the day of a Full Moon.

1 During the day, clean your crystal by placing it in the sun for 20 minutes. Then polish it with a soft cloth. Say, "I charge this crystal with the solar energy of magnetism."

2 That evening, charge your crystal by the light of the Full Moon, leaving it outside or on a windowsill overnight. Say, "I charge this crystal with Lunar energy of receptivity."

3 The next morning, your stone will be ready to carry with you. Let it become a daily companion. At least once a day, hold it to your solar plexus and take a deep breath. Say, "I draw all things needed with ease and grace."

4 Whenever you find yourself tempted to overspend, pull out this stone and sit with it. Allow it to remind you of the simple pleasures in life, and that you can derive more joy from experiences than from objects. Center yourself in gratitude for this gift from the earth.

5 Every Full Moon, repeat the process to keep your crystal charged.

The Gods and Goddesses of Abundance

This ritual calls upon the deities associated with abundance to bring you good fortune. Fire, Water, Air, and Earth serve as offerings to create an energetic exchange.

You'll need eight green and gold stones; Green Tourmaline is especially powerful. You'll also need a crystal generator (see page 20), a votive candle, some incense, and a small glass of water.

1 Begin by setting your generator on a table or altar. Place the rest of your crystals radiating out to the four directions and to the cross quarters.

2 Place the water on the left side of your crystal grid and the candle on the right. Light the candle and the incense and waft it into the air above your stones.

3 Say, "I call upon Lakshmi, Goddess of Wealth, Ganesh, remover of obstacles, and Fortuna, Goddess of Fortune. I thank you for being present, and I ask that you assist in this working.

I call upon you to align me with the frequencies of success, self-worth, and true high-vibrational value. I ask that you help me find the courage to achieve great things. I ask that you bestow radiance upon me, and that I may allow my highest self to radiate outward in all aspects of my daily life. I ask that you help me magnetically attract healthy, positive people, fruitful opportunities, supportive structures, and enduring enterprise.

Ultimately, I ask that you bring me into alignment with my highest self, my highest potential, and my greatest good. So it is!"

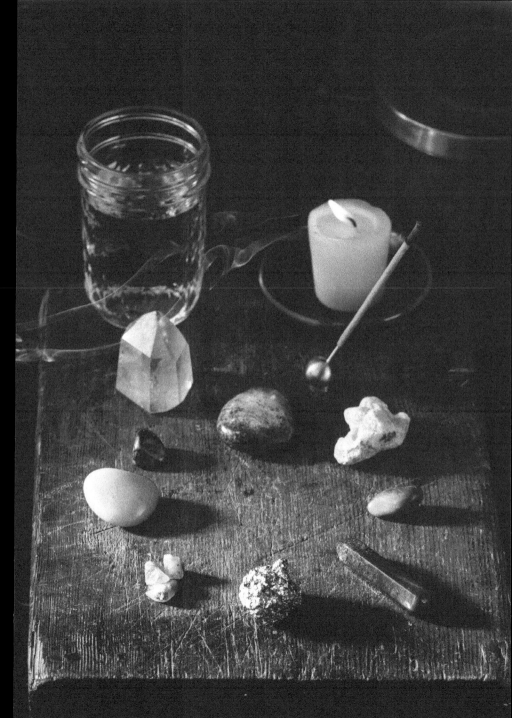

4 Sit before your grid in a meditative position and let yourself be filled with these thoughts and inspirations.

5 When you feel ready to close the ritual, give thanks and snuff out your candle. You may leave the grid set up for as long as you wish.

Share the Wealth

The universe returns the energy to us that we put out into the world. This ritual helps create happiness wherever you go and is also useful for releasing unnecessary attachment.

You will need any tumblestone or small crystal. You can charge them on your altar and imbue them with love and light. You can use new stones or crystals that you have had but no longer feel connected to.

You'll gift these stones to others as you send positive energy out into the world. Giving it freely allows the energy to flow back to you.

Look for these opportunities to share the powerful energies of crystal healing with the world:

- When leaving a tip: Place the crystal on top of the tip.
- When giving a a bag, purse, box, or other container as a gift: Tuck a stone into the pocket or place it inside as a gift within a gift.
- Person on the street: Give a crystal to a stranger as a random act of kindness. You'll be surprised how this small gesture can adjust the flow of energy in your life.
- As a thank you: Along with a note, include a crystal for someone who deserves acknowledgment and gratitude.

Finding Muses and Mentors

We can be more productive, innovative, and inspired in our work when we have mentors to guide us and muses to inspire us. Use this ritual to help draw these people into your life. It's best to perform this ritual during a New Moon.

Moss Agate and Serpentine are good choices for this ritual, but you can use any of the stones listed in this chapter (see pages 69 to 73). You can also add Clear Quartz points, as many as you like. You'll also need a pen and a journal.

1 In your journal, write a list of five people who inspire you. They can be anyone—people you know or people that you only know of. They can be friends or family, authors that you admire, successful people in your chosen field, or anyone that you feel has had a positive influence in your life.

2 Now put each name at the top of a page and list the attributes that you admire and respect about this person. You can be specific or general; just list the qualities that come to mind.

3 When you are finished, read through the list of attributes. Find where you have listed the same things two or more times across the lists. These are the most important qualities for your own personal wavelength.

4 Hold your stone in your projective hand and say, "I place this call out to the universe. May I send out the frequencies of [read your list of attributes, with the most important qualities first]. May I attract muses and mentors who also radiate this frequency."

5 Tear out your list of inspiring individuals or write them down on another small piece of paper. Place this list in your wallet.

6 On another small piece of paper, list the top five attributes from your lists. Place this underneath your crystal while it's on an altar or in an area of your home that is uncluttered. Place the Clear Quartz points around the stone, facing outward.

7 Visualize this crystal sending out these frequencies like a radio tower, to be received by those who understand this message, and draw them forward into your awareness.

8 Leave the stone set up as long as you wish, or at least until the next New Moon.

Diminishing Debt

The more our debt adds up, the more stressed out we can be—as it seems to be never-ending. Use this ritual to help you address your debts and make progress without being overcome by anxiety.

Yellow Fluorite and Jasper work well for this ritual, but you can also use other grounding stones. You'll need a box in which you can store some paperwork.

1 Within your box, place all your bills, IOUs, and other notices that you are paying off. Make sure that everything is in there, but do not put anything inside that is not bill- or debt-related.

2 Hold your crystal in your receptive hand. Close your eyes and take some deep breaths. Center yourself in a commitment to relinquish debt, scarcity, and lack.

3 Hold your crystal to your solar plexus. Breathe in the energies of empowerment, ability, stability, endurance, and courage. Let these energies flow throughout you for a few minutes as you attune to these vibrations.

4 Take one more deep breath, and, as you exhale, open your eyes. Place your crystal in the box. Whenever you need to address your bills, you'll have it there to remind you how to center yourself. Soon you'll find yourself chipping away at the debt, moving forward one day at a time.

Easier Organizer

Crystals can be great for getting organized, because that is exactly what their underlying crystalline structure represents: organized growth patterns. Use this ritual when you need to streamline specific areas of your life. An organized life makes it easier to be productive, balance personal and professional life, and stay one step ahead of the game.

Good stones for this ritual are Pyrite, Malachite, Yellow Fluorite, and Green Tourmaline, but you can program any abundance stone with this energy.

1 Hold your cleared and charged crystal in your receptive hand as you center yourself with some deep breathing and relaxation.

2 Close your eyes and visualize a channel of light descending from above. See it moving down through your crown, through each of your chakras, and pausing at the solar plexus. Here, take a deep breath and let the light descend the rest of the way through your root chakra and down into the floor. Feel your entire system aligning, and feel your subtle bodies falling into order.

3 After a few minutes, get up and place your crystal in your pocket as you spend the next 30 minutes organizing items in your home. Keep your focus, and don't let yourself become distracted. Here are some suggestions:

- Stack any loose papers in neat piles.
- Straighten your bookshelf.
- Turn all of the bills in your wallet faceup.
- Line up your shoes in your closet.
- Shift the jars in your pantry or medicine cabinet so the labels face the same direction.

Although some of these things might sound silly, you are creating an underlying pattern of organization in your home. This pattern can flow over into larger areas of your life so that organization comes naturally.

Honoring Values

To find the right path, job, career, or focus, it is important to know what your values are. The things that you value can change over your lifetime, so it is worth reassessing what is most important. This is especially true when you are looking to potentially change jobs, start a new project, or launch your career. Think of it as "going in" before "going out."

You'll need paper and a pen, your favorite abundance stone or stones, and a place on your altar.

1 On the paper, make two columns. In the first column, make a list of what you consider to be your best attributes. These are all the things that you bring to the table in life, whether in work or in your personal life.

2 In the second column, make a list of the qualities that are most important to you in your work, career, or collaborations. Things like *supportive team, healthy environment, respect, quality production, fair compensation, creative inspiration, and opportunities for growth* are better than specific details, places, people, or numbers. Think about underlying values—the things you're not willing to bend on.

3 See if you can connect the qualities listed in the first column to those in the second. See the contribution that you make to the whole and the way that it is reflected back to you.

4 Place this paper on your altar and put your crystals on top of it.

5 Sitting or standing before your altar, visualize a channel of light moving upward from the paper, through your stones, and beyond the ceiling.

6 Say the following: "I send my request to the universe to align my life with my values. To place me where I may best use my skills, gifts, and talents. I bear witness to my values, and I open myself to the paths that align with them, amplify them, and assist me in fulfilling my soul's purpose. So it is."

Now that our crystals are working to align us in love and abundance, there's one more key place to put them to work, and that is in the home. While they can be used as décor simply for their beauty, crystals are much more than just pretty objects to look at. Crystals can be helpful for everything from protecting and grounding a space to purifying negative energy and holding positive intentions in certain rooms.

CHAPTER 4

Home

SPIRITED DÉCOR AND OTHER RITUALS FOR THE HOME

YOUR HOME IS AN EXTENSION OF YOURSELF, and when the energy in your home feels joyful, clean, and vibrant, a healthy and happy life becomes so much easier.

When you are choosing stones to place in your home, you are free to explore larger stones and more fragile crystals since you won't be putting them in your pocket or carrying them with you.

If you already have some crystals in your home, this work might just be a matter of rearranging them and setting them with an intention to get them working for you. If you have them packed away, you can begin by taking them all out for cleaning and recharging. They spent their lives underground, and now they want to be in use and in the light! Remember to give the crystals in your home some regular love so they don't just feel like mannequins on display.

Stones that are on the cooler end of the color spectrum (greens, blues, and purples) tend to be calming, while those on the warmer end (reds, oranges, and yellows) tend to be more energizing. Keep this in mind when selecting stones for a specific room by evaluating if it's an area where you want to have plenty of energy or where you want to relax. Of course every person is different, so you might actually find that a cool-colored crystal feels energizing to you.

With all of these rituals, it is best to clean the room before setting up your stones. If you plan on keeping a crystal in a permanent location, clean the area well, both physically and energetically, by smudging with some sage or palo santo. Open the doors and windows to clear out stagnant energy before placing your crystals to fill your space with healing frequencies.

TOP CRYSTALS FOR THE HOME

BLACK TOURMALINE

Widely regarded as the most protective stone of the mineral kingdom, Black Tourmaline helps deflect toxic energy and disperse stagnation. You can wear it, place it in your home, or even keep it in your car to ward off negativity.

SMOKY QUARTZ

Smoky Quartz is unique in that it is both grounding and energizing at the same time. It can help anchor the energies in your home and also raise the vibration as well. Smoky Quartz corresponds to Earth energy, and a Smoky Quartz cluster or point can be perfect on a low table in any high-traffic area.

AMETHYST

Used classically as a stone to help release addictive behavior, the energy of Amethyst is calming and serene. In its cluster form, it's fantastic for energetic clearing in the home. Place it wherever you'd like a more spiritually aligned vibration.

SELENITE

Available in towers, palm stones, wands, and tumblestones, Selenite is one of the best stones for projecting and amplifying white light into a space. As it draws in light and reflects it outward again, Selenite appears to glow from the inside. Place it in any room that could use some brightness.

CLEAR QUARTZ

The most classic of all crystals, Clear Quartz will bring light and amplifying energy into any area of your home. Use it wherever you would like to direct or generate positive vibrations. A large Clear Quartz point or cluster can make a fantastic centerpiece in any room.

BLACK TOURMALINE

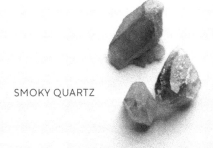

SMOKY QUARTZ

AMETHYST

SELENITE

CLEAR QUARTZ

LABRADORITE

LAPIS LAZULI

OCEAN JASPER

BLUE LACE AGATE

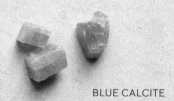

BLUE CALCITE

LAPIS LAZULI

Honored for millennia as a stone of the gods and goddesses, royal blue Lapis with golden specks of Pyrite is a stone of truth and wisdom. Placing it in your home fosters honesty and deeper knowing among anyone who resides there.

LABRADORITE

Revered as a stone of magic, the energy of Labradorite is dark and mysterious. Its hidden rainbow hues shine when turned toward the light. Labradorite is a powerful stone of psychic protection that keeps negative thinking and projections at bay and out of the home.

OCEAN JASPER

With its signature round "eyes," Ocean Jasper is said to be keeping a lookout for danger and is commonly used as a protection stone. You can place Ocean Jasper in your windows, and it is also a wonderful stone for detoxing.

BLUE LACE AGATE

Lovely and calming Blue Lace Agate will make you feel more peaceful just by looking at it. This stone is ideal to hold whenever you need to stop, breathe, and refocus. Placing it in your home will provide this same kind of vibration in your living space.

BLUE CALCITE

One of the most calming and nurturing of the Calcite family, Blue Calcite resonates with the energies of the highest self through creative self-expression. It harmonizes the energies of your home with healing, and it can help extract muscle tension or soreness. Place it on any area of discomfort for up to 20 minutes.

SHUNGITE

One of the most purifying stones available is Shungite. Mainly found in lake beds in Russia, Shungite has been found to clear toxins from water and from energetic fields. You can place pieces of Shungite in your water bottle or water dispenser, and you can also use it for protection in any area of your home where you feel you need better boundaries.

PURPLE FLUORITE

Known as the "psychic vacuum cleaner," Purple Fluorite helps clear out both internal and external blocks. It's an ideal stone to keep in homes that have a lot of people coming and going, to make sure that unnecessary energy doesn't linger.

CELESTITE

Said to resonate with angelic energy, Celestite sparkles with pale blue and invokes the clear sky. It lifts the vibration of your home and makes any space feel more spiritual. It's a perfect crystal to have in your meditation area or bedroom.

LITHIUM QUARTZ

With a light dusting or inclusion of mauve-pink Lithium, this crystal is one of the best for creating a calm and stress-free environment. Place it anywhere in your home where you want to neutralize stress and relax.

RUTILATED QUARTZ

With tiny golden threads of Rutile running through Clear Quartz, Rutilated Quartz acts just like a crystal battery. It increases the energetic flow of positivity through-out the home, and it is a great stone for the office, the living room, or anywhere that you want to turn things up a notch.

SHUNGITE

PURPLE FLUORITE

CELESTITE

LITHIUM QUARTZ

RUTILATED QUARTZ

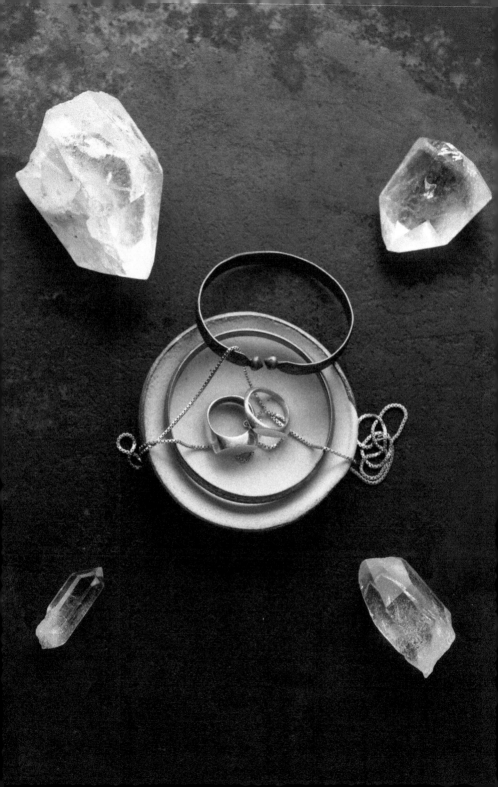

Charging Grid

You can use this charging grid to energize your jewelry, talismans, or other magical items. Placing stones in the center of the charging grid will raise their vibration to full power and make them potent for rituals and healing.

You will need four Clear Quartz points and a space (at least 8-by-8 inches) on a shelf or table to leave them set up. You'll also need sage or palo santo.

1 Begin by clearing the stones with the elemental energies of Water, Air, and Fire: Rinse them under cool running water and dry them, smudge them with some sage or palo santo, and let them sunbathe for about 20 minutes.

2 You'll now program each crystal for one of the four cardinal directions. Hold each stone individually in your dominant hand, with the point facing away from you, while you hold the following intentions.

3 First stone: Call upon the energy of the East, clarity and truth. Feel your stone filled with this energy.

4 Second stone: Call upon the energy of the South, inspiration and motivation. Feel your stone filled with this energy.

5 Third stone: Call upon the energy of the West, purity and receptivity. Feel your stone filled with this energy.

6 Fourth stone: Call upon the energy of the North, stability and protection. Feel your stone filled with this energy.

7 Form a square, with each of the crystals pointing inward from the direction they were charged with. There should be at least six inches left on the inside for you to place your objects.

8 Place the crystals, jewelry, or other objects you would like to charge in the center. You can leave them there for a full day or longer. You can place jewelry or stones you plan to carry with you there overnight and have them ready to go in the morning. Place them back there again the next evening to recharge for the following day.

Align with the Seasons

A good way to keep the energy of your home positive and in alignment with the cycles of nature is to do some deep clearing and harmonizing with the seasons of the year, which begin on the equinoxes (spring and fall) and the solstices (summer and winter). The spring and summer seasons are times to focus on outward growth and expanding your reach, while fall and winter are seasons for inner growth and work on the self.

These rituals should be performed within a 48-hour window of each event. The days slightly vary from year to year but always fall close to these dates:

- Spring Equinox: March 20
- Summer Solstice: June 20-21
- Fall Equinox: September 22
- Winter Solstice: December 21

You may use a single stone here or many. This is also a great ritual if you have a large crystal collection but can't put all your stones out at the same time, because you can feature different crystals for different times of the year.

You'll also need matches and a seven-day candle.

1 Begin by choosing the crystals from your collection that will be most representative of the upcoming season. You can choose based on color, properties, or whatever has the best "feel" of the season.

2 Do some deep energetic clearing of your home. Sage it out, sweep the floors, and clean your altar space.

3 Set up the stone or stones that you have selected on your altar and say the following: "May I align my purpose, intentions, and energy of my home with the energy of this upcoming season. I center myself here in the present as I initiate the [name the season]."

4 Light your candle.

Throughout the three months of the season, keep this area clear and light a candle whenever you feel the altar needs a little extra attention.

Protecting Your Entryway

This ritual helps you establish the threshold of your home so that you can keep negative energy out—whether from other people or situations—such as bringing home stress from work. It creates an energetic barrier and helps neutralize any disruptive energy that might enter your personal space through your entryway.

The best stone to use for this ritual is Black Tourmaline—the bigger, the better. You could also use another large black crystal or a silver stone, like Hematite.

A great time to do this is when moving into a new home. But if you don't plan on moving soon, it is always possible to reestablish the threshold of your home.

1 Begin by clearing and charging your Tourmaline. You can do this by placing it on a dish of coarse sea salt overnight during a Full Moon.

2 You'll now do a deep clean on the entryway of your home, both inside and outside. Make sure you thoroughly wipe down all four edges of your doorway.

3 While standing in your entry, hold your piece of Black Tourmaline in both hands as you say the following: "I charge this stone with the grounding and protecting energies of the earth."

4 Take a deep breath in and close your eyes. Send your awareness from your stone down into the earth. Continue downward deep into the earth, until you connect with its fiery iron core. Take a deep breath here, drawing this energy upward. With two more deep breaths, bring it all the way up into your body, to the center of your chest.

5 Take one more deep breath in. Then, as you exhale, direct this grounding and protecting Earth energy out and down your arms and into your crystal.

6 Place the stone directly on the floor in the corner that is closest to your front door.

7 Leave this stone there permanently, or until you move.

Clearing the Air

No matter how much we might try to keep the peace in our home, there are inevitably times when there may be bad news, arguments, or other negative energies that can hang in the air and bring down the mood.

It is always a good idea to clear any stones that have been in a room after an argument by rinsing them off (if they are okay to come in contact with water) and placing them in sunlight for half an hour.

You can then use this ritual to clear the air and reset positive energy. It also works great after having houseguests if you can feel any unwanted energies lingering.

You will need sage and a piece of Fluorite, Selenite, or Amethyst.

1. Begin by opening all your windows and doors. Light some sage and smudge out the space, walking from the main doorway in a counterclockwise direction.

2. Hold your crystal with both hands up to your chest. Close your eyes and feel your crown chakra opening. Visualize Divine Light energy flowing down into your crown and down into your crystal.

3. Take a few deep breaths as you find yourself in a place of peace, calmness, and centeredness.

4. Return to the doorway, and this time, raising your crystal over your head, walk around the room or space in a clockwise direction as you visualize these same energies radiating outward from your crystal and filling the home.

5. When you are done, place the stone in your main living space. You can place your other crystals around it to support this energy and continue to lift the energy of your home.

Stones for the Bedroom

The ideal energy of the bedroom is one of tranquility. The importance of restful sleep cannot be understated, as it is a time for unconscious healing of both the mind and the body.

After clearing the following stones by placing them in the light of the Full Moon, try the following placement in the bedroom. You can use these methods individually or combine them for a powerful crystal grid.

- Place a Selenite tower by the bedside. Selenite is a purifying stone that will keep the energy in your bedroom peaceful.
- Place Smoky Quartz under the bed to draw off any restlessness and allow deeper sleep.
- Place Labradorite under the pillow to assist with peaceful dreams and dream protection.
- Keep Rose Quartz by the bedside to hold during the night. Rose Quartz in the hand can assist in deep emotional body healing while you are asleep.

Bringing Sacred Spaces Home

One of the ways that you can create sacred space in your home is to charge your crystals with the high-vibrational energies of places that you visit throughout your life. This can include anywhere in nature (mountains, gardens, deserts, forests, lakes, and beaches) and also your own personal sacred places (temples, churches, monuments, and landmarks) and other favorite places.

When you go to these places you can take your crystals with you. While simply having them present in the space will allow them to absorb the frequencies, you can make the crystals even more powerful by setting them out and giving them some time to be still and absorb these energies more completely.

When you take them home, place them in your living areas to connect you back to these places. You can also use double-terminated crystals (see page 20) pointing outward from your charged stones to act like a bridge connecting you to these sacred spaces and channeling their energy into your home.

Days of the Week

Each day of the week corresponds to one of the seven visible moving celestial bodies, which are known as the seven classical planets (even though the Sun and Moon are not planets). The planets each have their own frequencies, and being intentional with your daily focus can help you maximize the efficiency of your day and help with your direction.

You'll need seven tumblestone-sized crystals for this ritual, one of each color that you see below, which you will assign to its corresponding day. A Selenite wand can serve as a very nice base to place these on.

- Sunday – Sun
 Yellow crystal, solar plexus chakra, "Shine as your best self"

- Monday – Moon
 Purple crystal, third eye chakra, "Open your mind"

- Tuesday – Mars
 Red crystal, root chakra, "Address issues"

- Wednesday – Mercury
 Orange crystal, sacral chakra, "Get creative"

- Thursday – Jupiter
 Blue crystal, throat chakra, "Speak your truth"

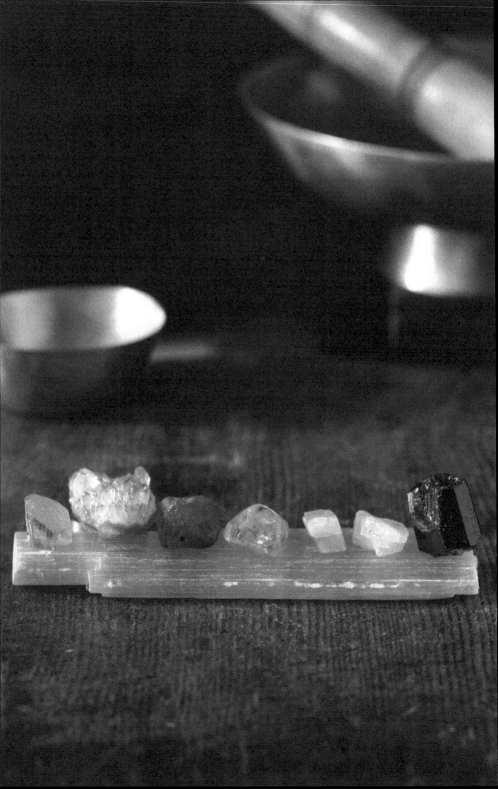

- Friday – Venus
 Green crystal, heart chakra, "Lead with love"

- Saturday – Saturn
 Black and/or white crystal, crown chakra, "Plant seeds"

1. Once you've chosen your stones, in turn, hold each one up to the appropriate chakra (see page 9) and state the affirmation out loud. The crystal will then hold that intention and serve as a touchstone and a reminder of your daily focus.

2. You may keep these stones on your altar, on a charging grid (see page 20), or on a Selenite wand in your bedroom or bathroom as you make this ritual a part of your morning routine.

3. Each morning, choose the appropriate stone of the day and carry it with you to align yourself with its intention. When you meet a moment of confusion or friction during your day, hold your stone and allow its intention to help you navigate the situation.

4. Place the stone back on your altar, charging grid, or Selenite wand at the end of the day.

Rainbow Maker: Chakra Attunement

Crystals can create rainbows as sunlight passes through them. They bring joy and welcome magic into your home. You'll need a Quartz crystal that either has a hole in it or has been wire-wrapped to attach the crystal to a necklace or string.

1 Hang your crystal or multiple crystals in a sunny window. West-facing windows work well, as light will shine into your home during most of the day.

2 As the sun hits your crystals and creates rainbows in the room, use this time to align with what rainbows represent. As a natural rainbow in the sky appears in the clearing that happens after a rain shower, rainbows symbolize hope and renewal.

3 This can also be a good time to call upon your spirit guides. Sit receptively and ask your guides, "Help me know you better."

4 You can also use this as a time to align your chakras with this simple attunement:

Sitting upright with a nice straight spine, visualize a ball of light in each chakra center. Take a deep breath at each point and say each affirmation as you move your awareness up from your tailbone to the top of your head. Take as much time as you need to make sure you can see the ball of light before you move on to the next one.

At your root chakra, visualize a deep red sphere of light: "I am grounded and protected."

At the sacral chakra, visualize an orange sphere of light: "I am creatively energized."

At the solar plexus chakra, visualize a golden yellow sphere of light: "I am strong and successful."

At the heart chakra, visualize a deep emerald green sphere of light: "I am balanced and grateful."

At the throat chakra, visualize a royal blue sphere of light: "I am present and truthful."

At the third eye chakra, visualize an indigo sphere of light:
"I am activated and aware."

At the crown chakra, visualize a white sphere of light:
"I am connected to Source."

Return to your heart center.

Knot Breaker

Areas that have a lot of electrical items plugged in to a single outlet or lots of cords, such as an office space or entertainment center, can create "energy knots" where electricity gets bundled. If you are sensitive to electrical energy, you can use this ritual to clear out energy knots in your home.

You will need a Selenite wand, a candle, and a few pieces of Black Tourmaline.

1　In the center of your home, light your candle as you say, "As I light this candle, I invoke the Divine Flame."

2　With your Selenite wand, walk throughout your home, "combing" the wand (moving it in a sweeping motion away from you) through any areas where the energy feels dense. Make sure to get any corners, especially toward the ceiling.

3　Whenever you feel that your wand has pulled a lot of energetic knots, point it toward the candle flame and blow on the wand forcefully, directing any drawn energy to be transmuted by the candle. Be sure to stand far enough away so that you don't accidentally blow out the candle.

4　Once you have gone through the entire home from top to bottom, take the Black Tourmaline and place it in any areas where you have a lot of electrical items plugged in. You can place a piece

directly on top of an outlet or a power strip. Black Tourmaline helps disperse electrical energy and can prevent the formation of energy knots. You can leave it there permanently.

5 When you are done, return to the candle and say, "I now affirm this work complete. So it is!" Blow out the candle.

Grounding and Protection Pyramid

You can use this ritual to create energetic protection for either a single room or around your entire home. The pyramid is one of the shapes of sacred geometry that has been used since ancient times. Its four faces represent the four elements. The point at the top represents Spirit, and the four-sided base represents a solid foundation.

For this ritual, you'll need four pieces of Clear Quartz. You should clear them and charge them with water and sunlight so they'll be raised to their highest vibration.

1 Follow steps 2-6 of the Charging Grid ritual (see page 109).

2 Place these four stones in the four corners of your home, or in the four corners of a room.

3 Stand in the middle of the room or your home and center yourself with some deep breaths. Focus on your feet.

4 Imagine drawing light up from your feet to the base of your spine and continuing upward through every chakra and out from your crown. Send your awareness up to the ceiling directly above you, then even farther still until you are aware of a space about twenty feet above your head.

5 Visualize energy from Source descending to meet your awareness there. Then picture drawing energy down from this point to each of the four crystals at the corners, one at a time. When you have visualized all four, you will have created an intentional energetic pyramid around your home.

6 Maintain this visualization as you state the following: "May this space be grounded and protected, in the name of all that is of the light. So it is."

Elemental Talismans

Programming your stones to represent the four elements can be useful for many workings in the home. You can use them as a grid for charging your magical items, to focus during meditation, and to hold your intentions and prayers. By using each of the four elements, you are making space for Spirit to work.

For this ritual, you'll need an area in your home where you can leave the grid set up that you'll create. It doesn't need to be a big area, but you want to make sure that other items do not accumulate there. You'll need four stones for this ritual, one of each color: red for Fire, blue for Water, yellow for Air, and green for Earth. These are the traditional elemental colors of the Western esoteric traditions, and if your personal tradition uses different color associations, please feel free to defer to those.

Hold each stone as you imagine its properties radiating from the crystal and into your space.

- Red: "May the elemental Fire of my home be tempered, contained, and controlled in a way that I may use it to fuel my passions and light my way."
- Yellow: "May the elemental Air of my home be crisp and clean. May I use it to have an open mind and focus my vision."

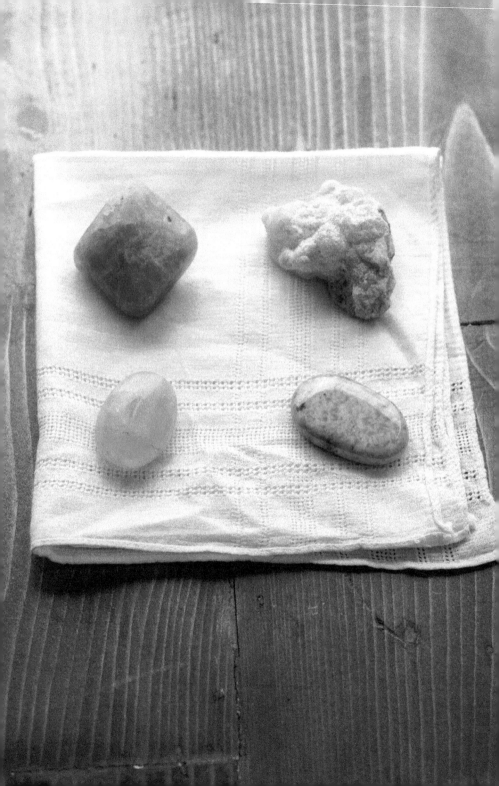

- Green: "May the elemental Earth of my home create safety and protection. May it guard me against any unwelcome intrusion."
- Blue: "May the elemental Water of my home run clear and pure, and may it nourish me and keep the energies of this space free from stagnancy."

With each stone programmed, you can place them together in a square. Whenever you want to focus more on one element in your home, move that stone to the center and place the other three as a triangle around it. For example, when the Full Moon is in a certain sign, such as Virgo, you could place the element of that sign (Earth) in the center, supported by the other three.

Meditation Space

Meditation is key for releasing stress, centering the self, and opening to higher guidance. It can be hard to find the right space in your home for meditation, but if you set up your crystals for this purpose, you can create a little haven right at home.

Wonderful stones for a meditation space include Selenite, Celestite, Amethyst, and Clear Quartz. You'll also need sage, palo santo, and your Crystal Room Spray (see page 124).

1 Find an area of your home you can dedicate to this purpose. It should be large enough to fit a chair or cushion on the floor and be as far away from TVs and other electronic devices as possible. Meditation is best done in low light, so consider where you can dim the lights or light candles.

2 Clear the area with sage or palo santo.

3 Place a mat, cushion, or chair in the area for you to sit on.

4 On a low table, place the items that you would like in front of you during your meditation. They can be as simple as a candle or a more elaborate altar, but sometimes less is more.

5 Place your crystals before you on the table to use as a focal point (and to charge until you are ready to use them).

6 Before your meditation, use the Crystal Room Spray to raise the energy of the space. Then light your candle and take two stones from the table to hold in the upright palm of each hand.

7 Begin with 5 minutes of meditation. Gradually extend your time until you can find stillness for up to 30 minutes.

Crystal Room Spray

Crystal energy can be transmitted through water. By imbuing water with essential oils, you can create your own magical spray to lift the vibration of a room.

You will need a 4-ounce glass spray bottle, filtered water, and an essential oil, such as jasmine, sandalwood, lavender, or bergamot. You'll also need some crystals that are small enough to fit inside the mouth of the bottle. Good crystals to use are Amethyst, Blue Lace Agate, and Clear Quartz. You can use as few as one or as many as a dozen.

1 Begin by charging your crystals on an altar space or charging grid (see page 20). You can leave them there for up to three days to get them fully charged.

2 Fill your bottle with water and add approximately 20 drops of essential oil. If needed, you can add more, up to 40 drops.

3 Drop in your stones, screw on the lid, and give the bottle a shake. You'll hear the crystals clink against the inside of the glass.

4 Label the bottle with your personal power symbols, numbers, or with a single word or phrase, such as *Love and Light*, *Clarity*, or *Magic*.

5 Hold the bottle to your heart center as you state, "I charge this water with one hundred percent Divine Light, with the power to transmute any improper energies and raise the vibration of my space to its highest potential."

6 Place the bottle on your altar or charging grid for another three days as you hold the intention of its increasing energy.

7 Use this spray in the air around the house whenever you want to clear a space, change the energy, or bring in crystal-charged positive vibrations.

Programming with Intentional Reminders

Just because we have an idea about how we want to use a certain area of our home, it doesn't always mean that we do it. Places where we want to be productive, like our office, can turn into areas of distraction, and this makes it hard to stay on task. We want our bedroom to be a place of rest, yet we might get stuck on our phone instead of getting a good sleep. Use this ritual to program a stone with the intention you want in each room. It will align the space with that intention and serve as a reminder of what you want to accomplish in that space.

1 Begin with a crystal that feels appropriate for the room. Clear Quartz crystals are good, but you can use any stone that feels right.

2 After clearing and charging your crystal, hold it in your dominant hand as you state the program: "I program this crystal to be self-cleansing and raised to its highest frequency. I program this crystal to resonate with the energy of [state your intention here] and to help me harmonize with this frequency whenever I am in this space. I program this crystal to help me keep [what you don't want] at bay. I affirm this program fixed. So it is."

3 Place your crystal in an area of the room where you will see it easily. Place it near you when necessary.

Here are some examples:
- In the bedroom: resonate "sleep, rest, tranquility"; keep away "restlessness, worry, work."
- In the office: resonate "productivity, focus, efficiency"; keep away "overthinking, boredom, procrastination."
- In the kitchen: resonate "healthy choices, nourishment"; keep away "junk food."
- In the study area: resonate "focus, deep understanding, memory"; keep away "social media and distractions."

Crystals for the Bathroom

Your bathroom is a place both for getting ready for the day and getting ready to sleep at night. It is a place of transition, and a place where the energies of clearing and releasing come into play.

The best stones to place in the bathroom are ones that correspond to the Water element. Lithium Quartz, Agate, Calcite, and Smoky Quartz are all good crystals for the bathroom.

You can place them on shelves, and even put them in your bath or shower. Let these stones be a reminder that the Water element can also help with emotional body healing. As you partake in bathing or washing, you can release emotions that you are harboring. Simply keeping charged crystals in this space is all you need to make the bathroom a healing place.

Crystals for the Kitchen and Dining Room

It is said that the kitchen is the heart of the home. Along with your dining room, it is the place in the home where you nourish yourself and where people come together.

Here are a few ideas for incorporating crystals into this part of your home:

- Use crystals at place settings: If you are planning a dinner party, place a stone at each person's seat. Let yourself be guided to which stone each person will resonate with the most.
- Use crystals to charge your food: You can place a Clear Quartz point near a glass of water or plate of food to raise its vibration and imbue it with crystal frequencies.
- Crystal centerpiece: Place your crystals in a geometric pattern as the centerpiece of your dining table. A candle or tealights in the center can amp up the ambiance.

Clear Quartz Amplifier

This simple ritual can be used to create good energy where there is stagnancy in your home. If you have noticed an area that doesn't get used enough, or where you would like to draw more attention or be more engaged, use these steps to shift the energy.

This ritual is best performed on the first of the month.

Quartz, Selenite, and Celestite are all great choices.

1 Clear your crystal with the Air element. You can smudge it or use a bell or fan to clear and awaken it at the same time.

2 Charge your crystal with the Sun for 20 to 30 minutes in the early part of the day and with the Moon overnight. The Sun and Moon represent the highest expression of duality, and charging your crystal with both brings a balance of Water and Fire, feminine and masculine.

3 Place your crystal in the area of your home where you'd like to draw more attention. You'll find the crystal acting like a magnet of attention, and this space will become more and more inviting.

4 Once a month, recharge your crystal with both the Sun and the Moon.

Crystal Graveyard

One of the most commonly asked questions is what to do when crystals break. First, don't worry that it means something bad. Sometimes crystals break because they are delicate; sometimes they have just served their purpose. It is okay to glue a crystal back together if it can be repaired. If it is only chipped, you can still absolutely use it; a chip doesn't mean that it won't work. But, occasionally, the edges of a broken crystal might be too

sharp to handle, or the broken pieces are too small to use. You may want to consider making a crystal graveyard for these pieces.

A broken crystal should never be thrown in the trash. Crystals came out of the earth, and sometimes they are ready to go back in. You'll need an outdoor area and some coarse sea salt for this ritual.

1. Find an area in your yard or another outdoor area that you can use for this purpose. It doesn't need to be large at all. Use the sea salt to create a purifying perimeter for your crystal graveyard. It might be just 10-by-10 inches.

2. If you have broken crystals or pieces of crystals, place them on the surface of the earth and press them down into the earth gently. You do not need to bury them.

3. Place your hands over the stones and visualize running light and energy from above you, in through your crown, down your arms, and out of your hands to your stones. If you have a Reiki attunement or other healing attunement, you can send the stones some healing.

4. Give thanks to the earth and to the crystal Devas (see page 12). Ask that any programs be cleared and that the crystals be returned to their natural state and reunited with the source of the mineral kingdom.

5. Keep this area clear of debris, and let it serve as a reminder of the cyclical nature of all things.

Motivation for Maintenance

If you're one of the lucky people who actually enjoys housework, then you might not need this ritual. Use this ritual when you need an extra boost of motivation to tidy up, rearrange, or otherwise work around the house to maintain the good energy of your home.

You'll program a stone for this purpose. The best options are Clear Quartz or Smoky Quartz.

1 Make sure the stone you have chosen is cleared and charged.

2 Sit in a meditative position with the crystal in your receptive hand.

3 Close your eyes and allow yourself to connect with this crystal's frequency. As you do, begin a visualization. Picture your home when it is in its best energetic condition. Picture everything clean and sparkling: no clutter, no dust, and nothing out of place. Take a deep breath and really feel the enjoyment of this vision. Share this vision with your stone by sending your consciousness down to your hand.

4 After a few minutes, shift the crystal to your dominant hand as you say the following: "I program this crystal with one hundred percent pure light frequency. I program this crystal to be self-cleansing and to be an amplifier of clarity and cleanliness. I program this crystal to assist me in keeping the energy of my home free from clutter and mess. May it help me take on small tasks with ease and break larger ones down into smaller steps. I program this crystal to help me stay on target. I affirm this program fixed. So it is!"

5 By this point, you should now be inspired to get to work. Keep this crystal with you while you go about your chores. You can leave it on your altar or charging grid (see page 20) when you are not using

it. Whenever you need to do some housework, pick up this crystal and let its program frequency run through you and keep you motivated.

6 End whenever you are done, not when everything is perfect. Center yourself in gratitude for your work and call in a simple blessing for your home: "May this space be filled with love and light."

Creating a World Grid

Our home is not our only residence—we must also consider our "big" home: the planet on which we live. This very special ritual creates an energetic grid that connects you to your destinations and all the special points along your path.

You can use any crystals you want for this ritual. Small Lemurian Seed Crystals work especially well.

1 Before going on any trip, charge a stone to take with you.

2 Keep one crystal at home that will serve as the generator (see page 20) for your world grid that all of the other stones can energetically connect to.

3 Whenever you travel and arrive at your destination, "plant" a crystal there. You can place it in the ground, in a body of water, in the trunk of a tree, or in a temple or other sacred place.

4 You'll leave the stone there, and it will link energetically with you and the other stones you've already planted, and the ones you will plant in the future. In time, you will create a crystal network of all the special places you have visited.

5 You can also give a crystal to someone who is traveling some-
 where so that they can expand your grid for you even if you aren't
 going along.

6 When gifting a crystal to another person, you link your grid to
 theirs, making both bigger and even more powerful.

The Power Crystals

This section of the book introduces 100 crystals you can choose from to collect and incorporate into your rituals. Each crystal profile includes its corresponding element, chakra, qualities, and healing properties, as well as tips for charging and cleaning. Use the information here along with the tips in chapter 1 to choose the right crystal for any intention. The way you experience crystal energy will be unique to you, so always trust your own intuition first. You may surprise yourself when you discover that a crystal you felt calling out to you was exactly the one that you needed. You are already more attuned to the crystal kingdom than you realize. Refer to this directory often as you build your collection and your crystal practice.

CHAKRA COLOR GUIDE

ROOT CHAKRA	Red, Black, Brown, Silver
SACRAL CHAKRA	Orange, Peach
SOLAR PLEXUS CHAKRA	Gold, Yellow
HEART CHAKRA	Green, Pink
THROAT CHAKRA	Blue
THIRD EYE CHAKRA	Purple, Indigo
CROWN CHAKRA	White, Iridescent, Clear

AGATE

ORIGIN: Throughout the world

COLOR VARIATION: Banded Chalcedony in any color; popular varieties include Blue Lace, Blue Holly, Botswana, Peach, Moss, and Tree.

ELEMENT: Water

CHAKRA: Corresponds to the color of the stone (see the Chakra Color Guide on page 136)

QUALITIES: Creative stimulation, calmness, release

HEALING: With its alternating trans-lucent and opaque bands, Agate is a variety of Quartz that comes in all colors. Blue Lace Agate is one of the best stones to help you access and express your highest truth. Moss Agate and Tree Agate connect you to the realm of nature. All Agates have a soothing, calming effect. Just as they correspond to the element of Water, they help dissolve and dilute any undue harboring in the emotional body. The emotional body is the part of us that's linked to creativity, so releasing a block there can be just what is needed to get the creative juices flowing. Agate also connects us to our nurturing side, so they can be great stones to work with when getting new projects off the ground or when in the beginning stages of a relationship.

CARE: Rinse with water. Charge with moonlight.

TIPS: Place Agate under your pillow for deeper relaxation and dream-ing. Wear or hold Agate when your nerves feel frazzled or when you are dealing with grief.

AMAZONITE

ORIGIN: Brazil, Canada, India, Namibia, Russia. High-grade specimens come from Colorado.

COLOR VARIATION: Light greenish-blue with interlacing of white.

ELEMENT: Water

CHAKRA: Crown, throat , heart

QUALITIES: Connection, inspiration, balance

HEALING PROPERTIES: Amazonite bridges the mind, heart, and spirit. This stone assists in clearing communication of the heart's desires once they are healthy and aligned with your true purpose. It is useful for finding the right words to talk about feelings, whether through conversation, writing, or artistic endeavors. For this reason, Amazonite is a talisman for creative people who want to convey a message, an emotion, or a story. Like the sky reflecting in a crystal sea, Amazonite shimmers with chatoyancy (see page 20) and can be helpful when you need to look at an idea from multiple angles. Amazonite can be placed between two people during a conversation to help each of them speak from the heart and listen from their higher self.

CARE: Rinse with water. Charge with moonlight.

TIPS: Hold this stone during conversations, or while meditating to gain a deeper inner understanding of your desires. Keep it nearby when writing, especially words that should come from the heart.

AMBER

ORIGIN: All over the world, with the largest deposits in the Baltic region. The rare blue variety comes from the Dominican Republic.

COLOR VARIATION: Yellow, varying from golden to orange to brown. Very rarely found in blue.

ELEMENT: Fire

CHAKRA: Solar plexus

QUALITIES: Resiliency, strength, self-preservation

HEALING PROPERTIES: Amber is fossilized tree resin, which takes at least 100,000 years to form. As such, it can be used to align with the inherent strengths that have been passed down to you through ancestry or incarnations. Occasionally Amber contains fragments of preserved organic matter, such as plants or insects, symbolic of the stone's ability to aid in self-preservation. Amber is an important talismanic stone that can be used to boost self-value and self-awareness. Amber can also help unlock dormant talents that appear later in life. As it shines with golden light, it conveys the energy of the Sun and will make others take notice of your radiance.

CARE: Be careful with Amber, as it can shatter if dropped. Rinse with water. Charge by candlelight.

TIPS: Carry Amber when you need to remember your worth. Hold it to your solar plexus for extra strength and to balance the ego.

AMETHYST

ORIGIN: Found all over the world. Some of the deepest purple Amethyst comes from Uruguay.

COLOR VARIATION: Some unique varieties include Hourglass Amethyst from Morocco and the Brandberg Amethyst from South Africa. Long lavender Amethyst crystals come from Veracruz, Mexico.

ELEMENT: Air

CHAKRA: Third eye

QUALITIES: Focus, calmness, clarity

HEALING PROPERTIES: Amethyst has been used across time to help release addictive tendencies, whether those addictions are substances, thoughts, or behaviors. Ancient Greeks believed the stone would prevent intoxication and even carved drinking vessels from it. This stone helps calm and relax the mind, release worry and fear, and untangle a web of anxiety or spinning thoughts. Amethyst embodies the property of dichroism, the reflection of both blue and red light, which we see as purple. It provides balance between polarities, and is one of the best stones to work with to find balance in meditation, between home and work, or between two or more people.

CARE: Keep out of sunlight. Smudge with herbs or incense, or rinse in water.

TIPS: Hold Amethyst in your palm or place it on the third eye chakra during meditation. Amethyst clusters bring calmness to any environment.

AMETRINE

ORIGIN: Rare in origin. Found in Nevada, Ontario, Canada, South Africa, and India.

COLOR VARIATION: Contains both the purple of Amethyst and the gold of Citrine.

ELEMENT: Fire, Air

CHAKRA: Third eye, solar plexus

QUALITIES: Full-spectrum clearing, transmutation, amplification

HEALING PROPERTIES: The rare combination of colors in Ametrine makes it a powerful stone that can assist in transformation from outdated identities into a more evolved state. It helps you see what you are truly capable of becoming and assists in releasing what is holding you back. It is one of the best crystals for invoking the Violet Flame, a special clearing energy and gift from the Ascended Master Saint Germain. This purifying purple fire is visualized encompassing the entire auric body and burning away anything unneeded. Ametrine is also a balancing stone for psychic awareness and outward action; it helps boost confidence so you can act on your intuition and trust your inner knowing.

CARE: Keep out of sunlight. Self-cleansing. Charge by candlelight and with mantras.

TIPS: Carry or wear Ametrine when you are going through major life changes to make sure you move forward, not back.

AMPHIBOLE QUARTZ

ORIGIN: Brazil

COLOR VARIATION: Clear Quartz with red, orange, or brown inclusions. This stone is also called Angel Phantom Quartz.

ELEMENT: Fire

CHAKRA: All

QUALITIES: Transformation, evolution, activation

HEALING PROPERTIES: One of the highest-frequency stones of transformation, Amphibole Quartz is a crystal of the Phoenix, the legendary bird reborn out of its own ashes. Its energy assists you when going through major life changes. It can help you feel supported during change, even when there is no consistency around you. When you are ready for a complete transformation, this crystal serves as a guide. It is extremely clearing to the body's energy and useful in crystal healing on the body, especially at the crown or solar plexus. Amphibole Quartz can help you release resistance to the necessary changes in life that will take you forward into a time of rebirth and renewal.

CARE: Clear with 20 minutes of sunlight. Charge on an altar or by candlelight.

TIPS: Keep Amphibole Quartz with you during major life events. Hold it during meditation and allow its energy to move throughout your body.

ANGELITE

ORIGIN: Peru

COLOR VARIATION: A light blue form of Anhydrite.

ELEMENT: Spirit

CHAKRA: Crown, throat

QUALITIES: Angelic communication, higher guidance, deep healing

HEALING PROPERTIES: Crystal healers prize the dreamy, dusty-blue Angelite stone as one of the most powerful healing minerals. Found only in Peru, it carries its own unique vibration that is soothing, peaceful, and comforting to all layers of the subtle bodies: emotional, mental, and etheric (see page 7). It connects you to your guardian angels and helps you become receptive to their messages, creating a conscious connection to your Spirit guides. Angelite works on the mental body to quiet the inner voices of doubt and fear and replace them with reassurance of safety and security. Angelite also deepens your ability to interpret synchronistic messages such as angel numbers and other signs from the universe.

CARE: Do not put Angelite in water. Clean with a soft cloth. Charge on an altar.

TIPS: Hold or meditate with Angelite when you want to connect to your guides and guardian angels. You can also place Angelite on the body to help you unwind and release tension.

APACHE TEAR

ORIGIN: Southwestern United States and Mexico

COLOR VARIATION: A form of translucent Obsidian, this stone is volcanic in origin. It ranges from dark brown to translucent black.

ELEMENT: Fire, Earth

CHAKRA: Root

QUALITIES: Protection, extraction, grounding

HEALING PROPERTIES: At first glance, Apache Tear appears solid black, but when held to the light, it is actually transparent. In this way, this stone teaches us how to find light even in times of darkness. It helps reveal the underlying source of issues so we can do the work to solve the problem and not just treat the symptom. Apache Tear is said to absorb pain and grief so that deep emotional body healing can occur. It can also help you recognize actions that you may otherwise be oblivious to, and brings awareness to how your actions affect others. Apache Tear is useful in situations where forgiveness is needed. It offers stability and protection from demanding or controlling people.

CARE: Rinse with water. Charge with 20 minutes of sunlight.

TIPS: Place the stone under your pillow to help clear the emotional body while you sleep. Take it to work to assist in warding off nosey or pushy coworkers. Meditate with Apache Tear to find the underlying cause of an energy blockage.

APATITE

ORIGIN: Found throughout the world

COLOR VARIATION: Blue is the most common variety. Yellow and green are rarer.

ELEMENT: Air, Fire

CHAKRA: Throat (blue), solar plexus (yellow), heart (green)

QUALITIES: Encouragement, amplification, connection

HEALING PROPERTIES: Apatite can help release shyness and introversion. Often we don't say exactly what we think or mean because we're too concerned with how someone else might perceive it. Blue Apatite allows communication without unnecessary filtering. Its frequency also shortens the length of time from thought to word so the truth can be transmitted quickly without over-thinking it. Yellow Apatite helps you not hold back when it's time to take action. It can bring more confidence to those who are afraid of being in large groups, public speaking, or any situation that requires a spotlight. Green Apatite can be helpful in relationships if you're struggling to open up about your feelings.

CARE: Clear with bells or singing bowls. Charge on an altar or charging grid (see page 109).

TIPS: Carry or wear Apatite when faced with any situation where you might hesitate to say what you need to say or do what you need to do. It is a perfect stone for teachers or presenters.

APOPHYLLITE

ORIGIN: India

COLOR VARIATION: A Zeolite mineral, this stone is typically clear and sometimes has a very pale green tone. It commonly grows with Stilbite in either clusters or individual points.

ELEMENT: Spirit

CHAKRA: Crown

QUALITIES: Energy, amplification, spiritual awareness

HEALING PROPERTIES: With its glassy prismatic pyramids, Apophyllite appears to contain its own atmosphere. It conveys a powerful, high-vibrational frequency that can spark revelation and higher spiritual awareness. It is a stone to work with when you're looking to evolve and rise into a higher state of being. Wherever you are putting in effort to grow and level up in life, whether in spiritual efforts or in the material world, Apophyllite can help you see the progress you are making and recognize the sometimes subtle results of your work. Apophyllite helps you open to the possibilities of a higher potential than you may give yourself credit for. Its vibration also helps release apathy and infuse needed change with optimism instead of reluctance.

CARE: Clear by the Full Moon. Charge on an altar.

TIPS: Place Apophyllite on the third eye during meditation to open the mind, clear the aura, and stimulate intuition and spiritual awareness. This stone makes a great generator (see page 20) on crystal grids and is a powerful altar centerpiece.

AQUAMARINE

ORIGIN: Throughout the world

COLOR VARIATION: The blue variety of the Beryl family, ranging from pale blue to blue-green.

ELEMENT: Water

CHAKRA: Throat, higher heart

QUALITIES: Purification, reflection, tranquility

HEALING PROPERTIES: Aquamarine is a stone of the sea and has the purifying abilities of elemental water. It assists in the detoxification of negative thoughts and helps dissolve blockages in both the heart and the mind. It is a stone of reflection. It works as a mirror that can take you deep into introspection, helping you process and realize what might be more obvious to others than to yourself. It gently encourages the release of denial. Aquamarine aids communication by allowing ideas to be conveyed clearly and received clearly, and it encourages healthy cooperation and compromise rather than challenge and debate. It works well when two people need to get on the same page and allows all parties involved to align with what's best for the greater good rather than individual motivations.

CARE: Clear and charge with moonlight.

TIPS: Place Aquamarine on your bedside table to bring tranquility to the bedroom. Wear or hold it during heart-to-heart conversations.

ARAGONITE

ORIGIN: Morocco

COLOR VARIATION: This stone comes in star clusters that are reddish brown, or as a blue-and-white stone that's typically polished.

ELEMENT: Earth

CHAKRA: Sacral (star cluster); throat, crown (blue)

QUALITIES: Detoxification, release, breakthrough

HEALING PROPERTIES: Aragonite can help you blast through creative blocks, eradicate resentment, and dissolve anger knots. It brings you back to your own center instead of focusing on the actions of others, and serves as a reminder of what is truly important. It can promote confidence and assist in overcoming fear, especially of trying new things. Because it radiates out in all directions, it carries the vibration of a star or sun. It can help you realize which direction or choice will be best. It is a stone that assists in breaking free of limitations and encourages thinking outside of the box.

CARE: Do not place in water. Place on dry coarse sea salt to clear. Charge with 20 minutes of sunlight.

TIPS: Hold Aragonite to the sacral chakra and use deep breathing to break up anger knots, drawing energy in with the inhale and directing it down into the earth with the exhale. Keep it on your desk when working on projects that require creative inspiration.

ASTROPHYLLITE

ORIGIN: Rare in origin. Found in Canada, Colorado, Greenland, Norway, and Russia.

COLOR VARIATION: Black with rainbow flashes.

ELEMENT: Spirit

CHAKRA: Third eye, root

QUALITIES: Astral travel, self-acceptance, purpose

HEALING PROPERTIES: This stone is used for astral travel, a form of meditation used to explore the astral realm and higher dimensional understanding beyond the limitations of time and space. This exploration can lead to a deeper understanding of your purpose on earth. Astrophyllite can help you understand why you must face certain challenges in your lifetime.

When the same patterns repeat, it is often because you're not learning the lesson. If you are having a hard time understanding why you must repeat a negative occurrence, Astrophyllite can help you see beyond the issue to the true teachings that lie on the other side. It is through our challenges that we grow, learn, and get closer to our true self. Astrophyllite can be the guide to help us get there.

CARE: Smudge with sage or palo santo. Charge by candlelight or moonlight.

TIPS: Keep Astrophyllite with you when you find yourself coming up against the same hurdles again and again. Hold it during meditation or place it under your pillow for revelatory dreams.

ATLANTISITE

ORIGIN: Australia

COLOR VARIATION: This stone is a form of green Serpentine that contains purple Stichtite.

ELEMENT: Water

CHAKRA: Third eye, heart

QUALITIES: Balance, wisdom, past-life recollection

HEALING PROPERTIES: This very special composite stone is one of the few that links the third eye to the heart. It is useful for past-life recollection, especially of lives in which you were an initiate of wisdom teachings. It can help you remember what you studied and learned in other incarnations. It is also useful in doing deep soul repair of relationships that have a multiple-life history. Atlantisite also guards against being overly materialistic and putting too much focus on money or possessions. It can help you remember that everything flows and has ups and downs, and that eventually we all reap what we sow. Keeping this stone close can remind you that your hard work does pay off—just maybe not always in the way that you expect.

CARE: Smudge to clear. Charge by the Full Moon.

TIPS: Carry Atlantisite when you are working through deep relationship issues. You can also carry it to release fear of lack and money-related issues. This stone pairs well with Selenite.

AVENTURINE

ORIGIN: Northeastern United States, South Africa, Central Europe, China, India, Japan

COLOR VARIATION: The most common colors are pink and green. This stone can also be orange or blue. All Aventurine is a form of Quartz containing Fuchsite Mica.

ELEMENT: Earth, Water

CHAKRA: Heart (pink and green), sacral (orange), throat (blue)

QUALITIES: Positivity, heart healing, prosperity

HEALING PROPERTIES: A good stone to carry in your pocket and wear as jewelry, Aventurine is a must-have for any crystal collector. Sparkling green or pink Aventurine not only helps open the channels of luck and love, but is also a very healing stone for emotional issues and heartache. It is a stone of joy, and having it around will lift your mood. It is a crystal that resonates with the energies of Venus, which represents love, beauty, abundance, and fertility. It is amplifying as a Quartz crystal and encourages you to keep moving in a healthy direction in both love and work.

CARE: Rinse with water. Charge by the Full Moon or on an altar.

TIPS: Hold Aventurine to your heart when you need to open up to receiving love or support. Program green Aventurine as a magnetic money talisman.

AZURITE

ORIGIN: Throughout the world

COLOR VARIATION: A copper ore, Azurite is the deep-indigo relative of Malachite.

ELEMENT: Air

CHAKRA: Third eye, throat

QUALITIES: Higher thinking, flexibility, psychic development

HEALING PROPERTIES: Azurite helps you get past blocks by finding creative ways over, around, or through. When you are frustrated or stuck on something needing to be a certain way, you can hold or meditate with Azurite to open yourself up to possibilities you haven't yet considered. When you've had a hard time making a decision, holding Azurite can help you identify your best option—or sometimes introduce an even better one! It is a third-eye opener. Azurite also encourages meaningful conversation, allowing two people to go beyond surface topics and get deep. It is a helpful stone for teachers, writers, artists, and counselors.

CARE: Do not place in water. Clear with bells, singing bowls, or other air methods. Charge on an altar.

TIPS: Hold Azurite to any area on your body where you have joint or tendon pain as a result of overuse or repetitive motion. Just as it assists with flexibility in the mind, it can promote flexibility of the body as well.

BISMUTH

ORIGIN: Throughout the world. Rainbow Bismuth crystals are created in a lab setting as liquid Bismuth cools.

COLOR VARIATION: Primarily blue or gold, but contains the full rainbow spectrum.

ELEMENT: Spirit

CHAKRA: All

QUALITIES: Inner strength, chakra balance, timeless connection

HEALING PROPERTIES: Are you a person who connects to other decades or eras? Do people tell you you're an old soul? If so, you may benefit by having Bismuth as a healing crystal. Bismuth is a stone of timeless connection and can help you access past lives and ancient memories. Bismuth works on the entire chakra system. If you are doing a chakra healing, you can also substitute it for any other crystal.

CARE: Do not place in water. Handle Bismuth with care, as it is a soft mineral. It's not the best stone to carry with you, but it works well when placed on an altar and held during meditation.

TIPS: Place Bismuth at the center of a crystal grid to assist in your intentions and link your other crystals together. Hold this stone during guided meditations and sound baths to activate a deeper experience.

CALCITE

ORIGIN: Throughout the world. Most Calcite used for healing comes from Mexico.

COLOR VARIATION: Calcite comes in many colors: green, blue, red, gold, honey, salmon (pictured), aqua, white, and in banded combinations. Mangano Calcite is a special form that is pink and white banded.

ELEMENT: Water

CHAKRA: Corresponds to the color of the stone (see the Chakra Color Guide on page 136)

QUALITIES: Detoxification, extraction, comfort

HEALING PROPERTIES: Calcite is its own family of stones, and it is much softer than Quartz. It is an extractive crystal. Calcite acts like a sponge to draw pain away from the body, whether it's emotional, mental, or physical. These stones have a waxy feel as opposed to the glassiness of Quartz and provide comfort when held to any sore area of the body. Calcite can also be used to clear blocked chakras by holding the stone to that area and using breath and visualization to assist the chakra in opening.

CARE: Rinse with water. Charge with moonlight or Selenite.

TIPS: Place Calcite in your bathtub for a magical healing bath. For chakra healing, hold blue Calcite to a sore throat, green to the heart, and honey or gold Calcite to the solar plexus.

CANDLE QUARTZ

ORIGIN: Madagascar

COLOR VARIATION: This stone is usually milky white with one main crystal surrounded by many smaller crystals growing on the sides, which resemble candle wax. It's also called Pineapple Quartz.

ELEMENT: Spirit

CHAKRA: Crown

QUALITIES: Connection, harmony, support

HEALING PROPERTIES: Milky or opaque Quartz points are believed to have female energy, and clear points are believed to have male energy. When paired with a Clear Quartz point, the two can work together to balance one's energy. Candle Quartz carries spiritual wisdom and helps you connect to the universal consciousness. It brings greater awareness of synchronicity and the underlying patterns that connect all things on earth. Candle Quartz works well when you have a diverse group—either of people or ideas—and you want to find a common thread. As many crystals grow around the large central crystal, the stone is symbolic of support and the importance of the individual to the greater good. It promotes teamwork and harmony and helps everyone share a common vision while bringing their own unique gifts to the table.

CARE: Clear and charge on an altar or grid, and with bells or singing bowls.

TIPS: Lay Candle Quartz on the heart chakra pointing down to bring its energy and teachings into the body. Place it in physical spaces where multiple people are working together.

CARNELIAN

ORIGIN: Brazil, Madagascar, South Africa, Australia, India, the United States, Europe

COLOR VARIATION: This stone ranges from pale orange to deep red, sometimes with bands or areas of white or translucence.

ELEMENT: Fire

CHAKRA: Sacral, root

QUALITIES: Energy, sexuality, power

HEALING PROPERTIES: When you need encouragement or motivation, Carnelian is the stone to reach for. Stimulating and energizing, it helps get things started and keeps them moving. Carnelian can connect you to your inner strength and serves to remind you that you are safe. As a stone of sexuality, Carnelian can also stimulate passion in the bedroom. (Although you may not want to keep it near the bed while you sleep as it can be too energizing.) It is a great stone to keep in the office to enhance productivity. It encourages leadership, whether you're in that role already or are working on developing the properties of leadership in various aspects of your life. Carnelian can also be used to unblock the throat chakra.

CARE: Rinse with water. Charge with sunlight.

TIPS: Take Carnelian with you on days when you need to get a lot done, or into situations where you need to exert your strength.

CELESTITE

ORIGIN: Brazil, China, Madagascar

COLOR VARIATION: This pale blue stone exists in clusters, geodes, or as single crystals.

ELEMENT: Spirit, Air, Water

CHAKRA: Crown, throat

QUALITIES: Angelic connection, inner peace, spiritual environment

HEALING PROPERTIES: Celestite is a path opener and supports higher thinking, which helps the mind and heart strike a balance. It calms the inner argument and the internal debate, bringing about inner peace. It creates a more peaceful and spiritual environment wherever it is placed, which makes it a wonderful addition to any altar or meditation space. Celestite helps connect us to our guardian angels and can serve as a focal point during prayer or meditation. This stone helps restore faith and courage in those who are overcome with fear or worry, and it can also clear the air after arguments or traumatic experiences.

CARE: Handle this fragile stone with care. Cleanse and charge with moonlight or on an altar.

TIPS: Place Celestite as a centerpiece on an altar, shelf, or table, or at the center of a crystal grid.

CHAROITE

ORIGIN: Siberia

COLOR VARIATION: Swirling lavender, white, and black.

ELEMENT: Air, Spirit, Earth

CHAKRA: Third eye (primarily), crown, root

QUALITIES: Psychic awareness, inspiration, amplification, psychic grounding

HEALING PROPERTIES: A next-level psychic activation stone, Charoite amplifies the energies of intuition and the understanding of symbols, synchronicities, and enigmatic messages. If you are a naturally sensitive person who feels or sees these things but doesn't know exactly how to interpret them or use them, Charoite can help you to put the puzzle together. Receiving guidance through the crown, perceiving it with the third eye, and anchoring it in the physical world is the pathway of Charoite. When it is time to work with this stone, it will let you know, like the teacher who appears when the student is ready. You can use Charoite to deepen your understanding of relationships, collaborations, and the world in general. It can also be useful in bringing you down to earth when you feel psychically overstimulated.

CARE: Treat this stone gently. Rinse with water. Charge on a crystal grid or with moonlight.

TIPS: Place Charoite on the third eye during meditation to discover hidden meanings. Carry it with you when you are feeling bombarded with too much information and need help processing things.

CHIASTOLITE

ORIGIN: Australia, Russia

COLOR VARIATION: Pink, orange, or brown with a black X marking.

ELEMENT: Earth

CHAKRA: Root

QUALITIES: Protection, navigation, grounding.

HEALING PROPERTIES: Naturally containing the equal-armed cross, which is the sign for planetary Earth and the four elements, Chiastolite is a powerful talismanic crystal. It can be used to ground the energy in a home; it is also protective and anchoring. It is a stone of the crossroads and helps in being present in the moment. Useful in knowing which way to go next and opening the mind to possibilities, Chiastolite is like a treasure map with X marking the spot. It can help with your sense of direction and attune your inner compass. As such, it is also believed to help with dizziness, vertigo, or other physical imbalances. It is a stone for travelers, seekers, and those who are starting new ventures.

CARE: Rinse with water. Smudge with sage or palo santo. Charge on an altar.

TIPS: Carry Chiastolite as a talisman for finding your way. Keep it in your car if you get lost easily. It also makes a good center stone for crystal grids.

CHLORITE QUARTZ

ORIGIN: Throughout the world, particularly in Brazil

COLOR VARIATION: This stone has green or blue inclusions within clear Quartz.

ELEMENT: Water

CHAKRA: Crown, heart

QUALITIES: Amplification, heart-centering, clearing

HEALING PROPERTIES: Quartz with a Chlorite inclusion is a stone for working from the inside out. When we want to see changes in situations or relationships, we first need to focus our energy within to be sure we are contributing to the situation in an effective and positive way. Expecting external change is usually fruitless unless there is also some willingness to work on the self. Chlorite Quartz can assist in finding where and how to make these inner adjustments. Quartz amplifies the properties of Chlorite, which is very cleansing. This stone helps clear the chakras and subtle bodies, and will also help keep the energy of a home or workspace clear.

CARE: Rinse in water. Charge with herbs or in nature.

TIPS: Wear or place Chlorite Quartz on the body to clear the aura and keep your energy field at a high vibration. Place it in any room where ideas need to flow freely.

CHRYSOCOLLA

ORIGIN: Throughout the world. Most high-quality Chrysocolla comes from Peru.

COLOR VARIATION: Along the spectrum of blue-green, with occasional red or black specks.

ELEMENT: Water

CHAKRA: Throat, higher heart

QUALITIES: Empowerment, inspiration, nurturing

HEALING PROPERTIES: Chrysocolla is a copper ore, which is associated with Venus. It instills the properties of peace, beauty, love, and the Divine Feminine as gently as ink dropped into water. With its cool sea-blue jewel tones, Chrysocolla soothes and nurtures, and it assists in calming troubled hearts and moods. Showing you the way within, to the heart of the heart, it helps you channel your desires into focused plans, and honor those desires. Have this stone around in situations where you want to make healthy choices, especially regarding what you put into your body and how you allow yourself to be treated. It is a stone for healers, social workers, therapists, and caretakers.

CARE: Do not place in water. Clear and charge with air methods such as incense or sound vibrations.

TIPS: Use Chrysocolla in the kitchen to align with healthy eating habits, in the bathroom to take good care of your hygiene, and in the bedroom to align yourself with quality rest and peacefulness.

CHRYSOPRASE

ORIGIN: Australia, the United States, Myanmar

COLOR VARIATION: Light apple green to deep green, sometimes with a brown matrix (see page 21).

ELEMENT: Water

CHAKRA: Heart, higher heart

QUALITIES: Extraction, encouragement, liberation

HEALING PROPERTIES: Chrysoprase is the best stone for freeing yourself from fears, phobias, and nightmares. Many of these things are symptoms of an active subconscious and imagination, which is a gift when channeled into healthy creative outlets. This crystal works deeply on the subconscious mind to draw out the source of irrational fear and allow peace and balance to be restored. It is especially powerful for empaths, as they can naturally have a very open heart, which can take on too much energy from others—especially if others are in pain. Chrysoprase can help empaths view their sensitivity as an asset. It raises your awareness to the higher heart so that you can communicate from a place of love and not let feelings cloud your truth. Chrysoprase can also be protective around the home and can keep negative energy away.

CARE: Rinse in water. Charge near Selenite or Citrine.

TIPS: Place Chrysoprase under your pillow to counteract nightmares, night terrors, or sleep paralysis. Place upon the higher heart during crystal healing treatments.

CITRINE

ORIGIN: Brazil, Africa

COLOR VARIATION: Citrine ranges from pale yellow to amber single points. Most Citrine on the market is actually heat-treated Amethyst. You can recognize it because it is not yellow throughout and has white parts or looks very orange. While it will still work with the solar plexus, this version will not have the self-cleansing properties of true citrine.

ELEMENT: Fire

CHAKRA: Solar plexus

QUALITIES: Manifestation, amplification, empowerment

HEALING PROPERTIES: To boost your self-worth, your willpower, and realize your value, there is no better crystal to work with than Citrine. It amplifies your abilities to manifest, and brings attention to your work, particularly when you may feel unnoticed or underappreciated. Citrine can also help get you back on track when you feel that you have lost your way or forgotten your intention. It will amp up your drive and your productivity.

CARE: Do not leave in sunlight. True Citrine is self-cleansing and self-charging. Keep it clean with a cloth and let it do the rest.

TIPS: Carry or wear Citrine as a talisman of personal power. Keep it near your wallet, cash drawer, or anywhere where you want to see an influx of manifested abundance and prosperity.

DANBURITE

ORIGIN: Throughout the world, particularly in Mexico

COLOR VARIATION: Pink or gray clusters or single crystal points.

ELEMENT: Water, Spirit

CHAKRA: Heart, crown

QUALITIES: Amplification, energy, high frequency

HEALING PROPERTIES: Danburite is a high-frequency heart chakra stone that is all about finding what makes you special. Working with this stone in meditation, crystal healing, or on a grid opens the channels to help you see what sets you apart from the crowd. When you carry or wear it, it helps others see these qualities, too. It sends energy out like a broadcast and can be useful for sending distance healing or connecting to people far away. When you feel like you are ready to "graduate" from Rose Quartz, Danburite will take you to the next level. It flushes out the etheric body (see page 7) and can help you release old patterns in love and relationships.

CARE: Handle this stone with care. Rinse with water. Charge on an altar.

TIP: Hold Danburite up to your heart center with the point facing out to broadcast love outward, either to somebody specific, a group, or broadly to the world. For a deep boost of love vibration, lie down with Danburite on your heart center.

DIOPTASE

ORIGIN: Africa, Mexico, Russia

COLOR VARIATION: Deep emerald green.

ELEMENT: Water

CHAKRA: Heart, higher heart

QUALITIES: High frequency, activation, attunement

HEALING PROPERTIES: Dioptase is a very high-vibrational crystal that is useful in connecting to your spiritual path. This is especially true for those who are often told they have abilities as a healer or want to be of service to others but don't quite know how to connect to their gifts. It assists with attunement to healing modalities, like Reiki and energy healing, and allows you to see how you can make a greater contribution to the world. Dioptase is also useful for breathwork and yoga, amplifying your progress in these practices. If you have ideas in your periphery but need to bring them forward for deeper examination, you can place Dioptase on your third eye and focus your awareness there, using it as a doorway to get those ideas to the forefront so you can begin to explore them.

CARE: Clear and charge on an altar or grid.

TIPS: Place Dioptase halfway between the throat and heart chakras and let the energy flow in and through you. This crystal is better used when you're alone rather than carried throughout the day.

ELESTIAL QUARTZ

ORIGIN: Most come from Brazil, but this stone can also be found in India, Australia, Africa, and the United States.

COLOR VARIATION: This crystal ranges from clear to smoky in color and has smaller flat crystals growing on a larger stone.

ELEMENT: Spirit, Earth

CHAKRA: Crown, root

QUALITIES: Attunement, activation, deep healing

HEALING PROPERTIES: Elestial Quartz has a special growth pattern where the smaller crystals grow in a rhombohedral pattern and can look like a city of overlapping buildings. Smoky Elestial is used for deep clearing of ancestral patterns, past-life karma, and deeply embedded issues.

Clear Elestials open the crown chakra and release misguided or limiting dogma or beliefs. It helps direct our attention to exactly what we need to focus on and can instill self-discipline. All Elestials are powerful attunement stones that can help take you to the next stage of your spiritual development. They will help you attract the right teachers and allies, and open the doors of opportunity.

CARE: Self-cleansing. Charge with sunlight and moonlight.

TIPS: Take your Elestials with you when you're doing healing work with a therapist, in a group meditation, or part of any ceremonial ritual. You can use an Elestial in a bath ritual to raise the vibration of the water you're soaking in.

EMERALD

ORIGIN: Colombia, Brazil, Zambia, India

COLOR VARIATION: Green with a black matrix (see page 21).

ELEMENT: Water, Earth

CHAKRA: Heart

QUALITIES: Attraction, grounding, restoration

HEALING PROPERTIES: As the crystal of Venus—Goddess of Love and Beauty—Emerald is a stone of attracting and magnetizing love. As the archetype of the Empress, it also draws abundance, prosperity, and fertility, so it is especially good for people wanting to start a family. Useful in business and in relationships, it connects you to the idea that what is cared for can grow and provide a return, just like a planted garden yields flowers and fruits. Emerald helps restore your energy levels and can bring you back to an optimistic mind-set when you have gone through a period of negative thinking or feeling jaded.

CARE: Clear and charge Emerald by taking it outside and placing it in the grass or near a tree. An hour in nature will get it ready to work.

TIPS: Carry or hold Emerald when starting new business ventures, relationships, or when looking to attract either one. Spring is the time of year to make sure you have your Emerald out and about. Pair it with Ruby for an especially powerful combo.

EPIDOTE

ORIGIN: Pakistan, Africa, Austria, Mexico

COLOR VARIATION: Darkly translucent to opaque green striated crystals.

ELEMENT: Earth

CHAKRA: Heart, root

QUALITIES: Amplification, high frequency, protection

HEALING PROPERTIES: Epidote is a crystal of increase, amplifying whatever it is around. This makes it one of the best stones for working in grids, as it enhances programming and intention setting. It will increase whatever you are focusing on, so make sure that when you work with it, you have your highest goals in mind. When you run up against an obstacle, Epidote will help you get over, around, or through it, as long as you are focused on victory. But if you focus on the fact that you are stuck, it can amplify that as well. With this crystal around, it is hard to ignore problems. Epidote will bring you face-to-face with what is not working so that you must finally deal with it. Its lessons are not always easy, but they are valuable.

CARE: Clear with sage and charge with candlelight.

TIPS: Carry Epidote with you when you need a boost. Meditate and hold it when you've been avoiding dealing with issues and you need to finally get to the bottom of things.

FADEN QUARTZ

ORIGIN: Brazil, Pakistan, the Alps, Russia, Arkansas

COLOR VARIATION: Tabular shaped crystals with thin inclusions resembling fibers running down the length. Faden Quartz is double-terminated (see page 20) and often grouped.

ELEMENT: Spirit

CHAKRA: Crown

QUALITIES: High frequency, amplification, connection

HEALING PROPERTIES: Faden Quartz is a bridge builder. It is a stone that teaches us how to heal ourselves. It reconnects lost parts of the self and is useful for soul retrieval, attuning the chakra system, opening energy blockages, and reconnecting the mind, heart, and spirit when they have fallen into disharmony. Faden Quartz can also be used to bridge different planes and dimensions, for those who wish to build connections to spirit guides, personal guardian angels, and ancestors. When you are feeling disconnected and aren't sure why, meditation with Faden Quartz can bypass the need to figure it out and just put you back into the energy of integral connection. You can use it to reaffirm and reestablish interest in hobbies and activities you have forgotten about or let fall by the wayside.

CARE: Handle this stone with care. Clear with running water. Charge on an altar.

TIPS: Hold a Faden Quartz between two chakras to get them synced and working together.

FAIRY STONE

ORIGIN: Harricana River in Quebec and Ontario, Canada

COLOR VARIATION: White to gray or beige, with Calcite mineral deposits.

ELEMENT: Earth, Water

CHAKRA: Sacral, root

QUALITIES: Extraction, protection, grounding

HEALING PROPERTIES: Formed on the bottom of glacial lakes, these very special stones were named by the local Algonquins who saw them as talismans of luck and protection. They connect you to the healing of the earth and your role as a caretaker of the earth, as well as to the healing of your lineage and foundation. They channel healing along ancestral lines and down into the earth's core, guiding us to the source of family issues. Gently bringing these patterns to the surface, Fairy Stones can be great teachers of forgiveness, compassion, and letting go. They radiate old wisdom and a holistic understanding of the link between humans, animals, and the earth.

CARE: Handle this stone gently. Do not place in water. Clear by placing on dry coarse salt. Charge with herbs or take into nature.

TIPS: For deep ancestral repair, place a Fairy Stone beneath your pillow and carry it with you during the day. Place it in areas of the home or work where people could be more environmentally conscious.

FALCON'S EYE

ORIGIN: Throughout the world, particularly in Namibia, India, Brazil, and Canada

COLOR VARIATION: This stone is the blue variety of Tiger's Eye. It's also called Hawk's Eye.

ELEMENT: Air

CHAKRA: Throat, third eye

QUALITIES: Revelation, focus, vision

HEALING PROPERTIES: If you have a hard time finding your direction or seeing beyond what's right in front of you, you can benefit from carrying Falcon's Eye. This stone opens the channels so you can see your goals more clearly and discover the path that will get you there. It can help you maintain your focus and keep distractions at bay. Falcon's Eye will give you the confidence to turn ideas into action. It is a visionary stone and can help you get clearer on the message you want to bring to the world.

CARE: Clear with sage or incense. Falcon's Eye is best charged by simply being around you or other stones. It loses energy when left alone and unused.

TIPS: Place Falcon's Eye on your third eye during breathwork or meditation to connect to your destination. Carry it into situations where you need to stay focused.

FIRE AGATE

ORIGIN: Southern United States, Mexico

COLOR VARIATION: Combination of red, brown, and white with a rainbow flash.

ELEMENT: Fire, Water

CHAKRA: Root, sacral, solar plexus

QUALITIES: Purification, harmony, balance

HEALING PROPERTIES: Fire Agate is unique in that it is both fiery and watery, and restores balance between these elements. It is stimulating and supportive when needed. Both lunar and solar, Fire Agate holds the energy of the eclipse and is useful during these astrological events. It brings things to the surface that are ready to be released and purifies them with the transmuting energies of fire. It is motivating but not pushy. Fire Agate awakens the creative spark and gets things off the back burner and put into motion. It links our actions to our desires and assists with productivity and healthy creative expression. Fire Agate is also useful for relationships between two people who are fire and water signs, bringing balance to this polarized combination.

CARE: Rinse with water. Charge with candlelight or with sunlight and moonlight in equal measure.

TIPS: Carry Fire Agate when working on creative endeavors. Use during Full Moon rituals by placing it on a grid or an altar.

FLUORITE

ORIGIN: Throughout the world, particularly in China, India, and the United States

COLOR VARIATION: Green, blue, purple, clear, yellow, pink, and rainbow. Crystals form as rhombohedral Optical Calcite, octahedrons, or cubic clusters.

ELEMENT: Air

CHAKRA: Corresponds to the color of the stone (see the Chakra Color Guide on page 136).

QUALITIES: Extraction, clarity, focus

HEALING PROPERTIES: Fluorite frees you from overthinking, over-processing, and unnecessary speculating and analyzing. Its clearing vibration combs through energetic knots, untangling the mind when you have too many ideas or are receiving too many outside opinions. It can also help release headaches and migraines. Fluorite can help cut through the "noise," open the way for clarity, and make the decision process easier. It helps get rid of old ways of thinking that no longer serve you.

CARE: Keep out of sunlight. Rinse with water. Charge on an altar.

TIPS: Hold Fluorite to your head when you have a headache or feel like you're "in your head." Relax and breathe, and stay there for at least 10 minutes. Always remember to clear your Fluorite after you are done using it.

GARNET

ORIGIN: Throughout the world, particularly in India, Pakistan, China, and Canada

COLOR VARIATION: Red or green, also Star Garnet.

ELEMENT: Earth, Fire

CHAKRA: Root

QUALITIES: Protection, foundation, grounding

HEALING PROPERTIES: Garnet connects you to reality and gets your feet under you without a feeling of heaviness. It anchors you to the crystal core of the earth and activates the Earth Star, which is the lowest point of your energetic field (about a foot beneath the surface of the ground). Garnet helps motivate you to take your ideas and manifest them, preventing backsliding. It instills the intention to improve physical places and inspires you to leave any place better than it was before you were there. Garnet supports improvement in the material realm, of either your physical body or your physical home. It resonates with the energies of security and safety. It can help with the healing of childhood trauma by reflecting one's strengths and survival.

CARE: Rinse with water. Charge with sunlight.

TIPS: Place Garnet in your lap or between your feet if you're lying down to stay grounded during meditation. Use Garnet to ground your home, and keep it on you when doing home improvements.

GOLDEN HEALER QUARTZ

ORIGIN: Arkansas, Brazil

COLOR VARIATION: Clusters or single-terminated points. Quartz points have a golden color either as a coating or on the inside. Can vary from pale yellow to darker mustard yellow.

ELEMENT: Fire

CHAKRA: Solar plexus

QUALITIES: Amplification, restoration, deep healing

HEALING PROPERTIES: Prized by crystal healers, Golden Healer Quartz does deep repair on the etheric body (see page 7). It helps balance the ego by either releasing insecurity or tempering self-centeredness. For people who have had their self-worth diminished by traumatic events or abusive relationships, Golden Healers help by clearing the ties to the event or person and restoring self-love and personal power. The stone balances confidence with humility and releases the need to prove yourself, allowing your actions to speak for themselves. It is a perfect stone for those who want to lead by example. It helps when you need to pay more attention to your self-care, especially when you've been too focused on caring for others.

CARE: Smudge with palo santo. Charge with sunlight or candlelight.

TIPS: Carry Golden Healer Quartz when you need to recover your sense of self. Place it on a grid or altar to draw your energy back to yourself when you feel that you've been giving it all away to others.

HEMATITE

ORIGIN: Brazil, China, North America

COLOR VARIATION: Usually metallic silver. In its raw state or within other minerals it appears red.

ELEMENT: Earth, Fire

CHAKRA: Root

QUALITIES: Protection, deflection, grounding

HEALING PROPERTIES: Hematite has mirror-like qualities and is useful when you need to stay focused to complete a task. It helps you put your energy into the things that are going to have the biggest payoff and helps you avoid giving up when the going gets tough. It is also protective, as it reflects negativity away from anyone who holds or wears it. With its heavy weight, Hematite invokes a healthy sense of security and will keep you grounded when you feel overwhelmed. It releases nervousness and social anxiety. Hematite can be helpful for those who have a hard time setting boundaries and can serve as a touchstone as those boundaries get established.

CARE: Rinse with water. Charge with sunlight.

TIPS: Carry Hematite when you want to stay on track with work or hit deadlines. If loud or busy social settings give you anxiety, carry or wear Hematite to feel safer and more in control of your personal space.

HEMATOID QUARTZ

ORIGIN: Throughout the world

COLOR VARIATION: Brown to reddish Hematite inclusions in Clear Quartz, sometimes as an outer coating or appearing inside as phantoming.

ELEMENT: Fire, Earth, Spirit

CHAKRA: Crown, root

QUALITIES: Activation, grounding, transformation

HEALING PROPERTIES: Both grounding and amplifying, this crystal attunes the chakra system from top to bottom and releases blockages in the etheric body. With more pranic energy (see page 21) free to flow, Hematoid Quartz stimulates motivation and drive, harnessing one's ambition and directing energy into creative activities. It amplifies one's ability to make a positive contribution on both small and large scales. It clears out self-sabotaging tendencies and helps to replace negative and pessimistic narratives with positive, encouraging ones. As it bridges the higher spiritual faculties with the material realm, Hematoid Quartz can help you have clearer awareness of the physical results of activities like prayer, ritual, and meditation.

CARE: Do not place in water. Clear and charge with sunlight for 20 minutes.

TIPS: Carry or meditate with Hematoid Quartz to help break the cycle of starting things and not finishing them. Keep it with you until you have completed the task or project that you have been dragging your feet on.

HERKIMER DIAMOND

ORIGIN: Herkimer, New York

COLOR VARIATION: Small, crystal-clear double-terminated crystals (see page 20) with a short distance between terminations. Similar stones from Pakistan are called Pakimer Diamonds.

ELEMENT: Spirit

CHAKRA: Crown

QUALITIES: Amplification, activation, clarity

HEALING PROPERTIES: One of the best stones for opening the crown chakra, Herkimer Diamonds connect you to your highest self. It is a very high-vibrational form of Clear Quartz and has a similar vibration to actual diamonds. This stone shortens the length of time between asking and receiving and assists with spiritual awakening. Herkimer Diamonds open the doors to inspiration and can encourage breakthroughs when you're struggling to figure out your soul purpose. They can elevate your mood and spirit when you're in need of a powerful energetic boost. Naturally double-terminated, they help move energy in two directions and are powerful transmitters when you want to broadcast a message out to the world. They are easily programmed and keep you in the mindset of positive affirmations.

CARE: Rinse with water. Charge on an altar or charging grid (see page 109).

TIPS: Program your Herkimer Diamond by placing it in the center of a charging grid and focusing your intention. Use it to connect with a single affirmation and mantra.

IOLITE

ORIGIN: India, Madagascar, Myanmar, Australia

COLOR VARIATION: Indigo/purple, sometimes with inclusion of Sunstone (see page 227).

ELEMENT: Air

CHAKRA: Third eye, throat

QUALITIES: Activation, connection, balance

HEALING PROPERTIES: A stone that helps develop your intuition, Iolite opens the mind and third eye chakra in a way that lets you know the difference between fantasy and reality. It helps you make decisive progress without overthinking. Iolite balances the two sides of the mind so that you can use both logic and intuition to come up with creative solutions. It also helps balance the inner masculine and feminine parts of one's personality. Iolite works especially well when paired with sound-healing modalities, such as sound baths, tuning forks, or music meditations. It helps you take your visions and higher ideas and formulate them strategically so they can be explained and executed. It is a good stone for teachers and mentors.

CARE: Rinse in water. Charge by the Full Moon or on an altar.

TIPS: Meditate with Iolite when you want to explore the astral realm or strengthen your imagination. Place Iolite on the third eye during sound baths.

JASPER

ORIGIN: Throughout the world.

COLOR VARIATION: There are many varieties of Jasper. The more common varieties include green, red, yellow, Kambaba Jasper, and Cobra Jasper. A recently found version is called Bumble Bee Jasper.

ELEMENT: Earth

CHAKRA: Corresponds to the color of the stone (see the Chakra Color Guide on page 136)

QUALITIES: Protection, stability, grounding

HEALING PROPERTIES: No matter how hard you work and how much you attract in life, if you are ungrounded or ungrateful, what you receive will either leave again quickly, always feel unstable, or create more of a problem than its worth. That is true of both money and love. Jasper helps bring consistency to these parts of your life. Jasper's slow-moving frequency encourages you to take your time and appreciate what you have and what you create. It helps you see the value in simple pleasures and connects you to nature and the earth. It soothes frazzled nerves. Jasper is useful for following through when you have been stuck in a pattern of false starts.

CARE: Smudge with sage to clean. Charge on an altar.

TIPS: When you feel like you're spinning your wheels, take some time to hold and meditate with Jasper so that you can get some traction under your feet. Carry Jasper as a reminder to let things unfold at their appropriate pace.

KYANITE

ORIGIN: Throughout the world

COLOR VARIATION: Commonly blue, but also found in green, orange, black, and teal.

ELEMENT: Air

CHAKRA: All

QUALITIES: Clarity, balance, connection

HEALING PROPERTIES: Kyanite is one of the only crystals that resonates at a vibration that can never pick up negative energy. It never needs to be cleansed or cleared as long as it is worked with regularly. It clears the aura and other crystals, jewelry, and magical items when they're placed nearby. Kyanite amplifies altars, crystal grids, and mandalas, helping to broadcast their energy outward. It is a connecting stone, useful for communication with spirit guides and the angelic realm. It can also help people who are having communication issues reach a breakthrough and hear what the other is saying.

CARE: Kyanite is self-cleansing and does not need to be placed in water or charged.

TIPS: Carry Kyanite to keep your chakras balanced and your aura clear. Place it on the body vertically to move healing energy throughout your system. You can also place it in the home in areas that feel heavy.

LABRADORITE

ORIGIN: India, China, Madagascar, North America, Australia

COLOR VARIATION: Iridescent with yellow, gray, purple, blue, and green. Varieties that include more rainbow tones are called Spectrolite.

ELEMENT: Spirit, Fire

CHAKRA: All

QUALITIES: Protection, reflection, vision

HEALING PROPERTIES: Labradorite is a shielding stone that's useful for people who are sensitive to psychic energy. It is a stone of magic and can amplify your rituals, candle work, and magical ceremonies. It also helps you remember your dreams and understand their meanings, so it is useful for dreamwork or lucid dreaming. Labradorite can also be used for scrying, in which the crystal is used as a backdrop for clairvoyant visions (see page 21). It is very activating to your psychic centers. Along with its protective properties, it assists you in delving deeper into your own psychic ability without the influence of others and gives you courage to explore the astral realm.

CARE: Rinse with water. Charge by candlelight.

TIPS: Carry or wear Labradorite to keep negative psychic energy away. Place it under your pillow for dream recall and lucid dreaming. Place it on the third eye during meditation for deeper visions.

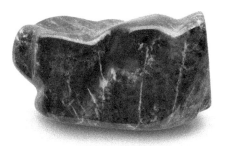

LAPIS LAZULI

ORIGIN: India, Pakistan

COLOR VARIATION: Deep blue with veins of white Calcite and speckles of gold Pyrite.

ELEMENT: Air

CHAKRA: Throat

QUALITIES: Protection, empowerment, ambition

HEALING PROPERTIES: With a history of magical properties going all the way back to ancient Egypt, Lapis Lazuli is regarded as the stone of truth, whether it pertains to deciphering what you hear or speaking your own truth clearly. It amplifies ambition and can be especially powerful when carved into obelisks, pyramids, and generators (see page 20), as these forms help maximize the strength of its vibration. As a power stone, Lapis Lazuli guards its wearer from closed-mindedness, pessimism, and uncertainty, and helps them deliver ideas in a way that others find inspiring. When reading or studying, it can help you retain information and commit it to memory.

CARE: Rinse with water. Charge by the Full Moon.

TIPS: Place Lapis Lazuli on the throat for 10 minutes before going into an important conversation. This will clear your throat chakra and help you find your voice. Place it in areas of your home where you want to increase the flow of movement and energy.

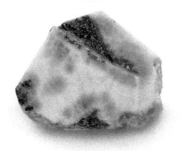

LARIMAR

ORIGIN: Dominican Republic

COLOR VARIATION: Turquoise and white swirled together.

ELEMENT: Water

CHAKRA: Crown, throat, heart, higher heart

QUALITIES: Detoxification, calmness, comfort

HEALING PROPERTIES: One of the most powerful crystals of the Water element and coming from only one location in the world, Larimar evokes the sea and its purifying power, dissolving your worries in its soothing surf. It is detoxifying, nurturing, and gently helps you digest emotional pain and dilute excess weight. As its energy washes over the heart, it helps you delve deep into the self, initiating introspection and soul-searching. When you want to discover the depths of your desire, Larimar can guide the way. It is a powerful talismanic stone for those who have an important message to share with the world, as it can help draw attention to the speaker. Larimar reminds us that everything has an ebb and flow, encouraging us to accept things as they are.

CARE: Rinse with water. Charge by the Full Moon.

TIPS: Keep Larimar with you to sync into the natural cycles of life, whether they are outer (such as the seasons or Moon cycles) or inner (such as your own moods and monthly cycles). Wear it as a pendant over the throat when you want to be heard.

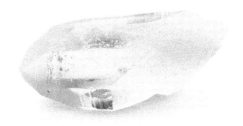

LEMURIAN QUARTZ

ORIGIN: Brazil, North America, Tibet, Russia

COLOR VARIATION: Pink, red, yellow, golden, smoky, or clear. The stone is also called Lemurian Seed Crystal.

ELEMENT: Spirit

CHAKRA: Corresponds to the color of the stone (see the Chakra Color Guide on page 136)

QUALITIES: High frequency, attunement, ancient wisdom

HEALING PROPERTIES: With its raised, barcode–like etching on the side, Lemurian Quartz is said to be programmed with the ancient wisdom of the lost civilization of Lemuria. These crystals were said to have been "planted" all over the earth and beyond until the time when they would be useful to those who found them. A Lemurian Quartz can become one of the most powerful crystals in your collection. It vibrates with the energy of Divine Unity, helping you feel the interconnectedness of all things as it connects you to the Lemurian energy grid. These crystals are high-frequency healers of cosmic consciousness and can awaken the ancient wisdom held within your own DNA.

CARE: Self-cleansing and self-charging, it's best if you do not let others handle your Lemurian Quartz.

TIPS: Hold a Lemurian with the ridges facing toward you, between your thumb and forefinger. Rub your thumb back and forth along the etched sides as you sit in a receptive state. Allow yourself to receive its wisdom.

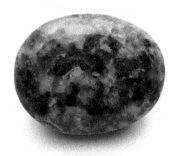

LEPIDOLITE

ORIGIN: Brazil

COLOR VARIATION: These lilac or rose-violet stones are typically found as tumblestones or layered in sheets of Mica.

ELEMENT: Air

CHAKRA: Third eye, crown

QUALITIES: Restoration, calmness, elevation

HEALING PROPERTIES: Like its close relative Lithium Quartz (page 188), Lepidolite also contains the mineral Lithium and is useful in releasing stress and anxiety. It soothes the mental and emotional bodies and helps lift clouds of depression and heart-heaviness. Lepidolite reminds us that our heart and mind have many layers, and even a small shift can begin a new cycle moving in a better direction. It helps with self-forgiveness and the release of self-judgment, especially when the mind is getting in the way of the heart's healing. Lepidolite teaches us to stop focusing on the surface of our shortcomings. If we soften our gaze and look through them instead of at them, we will see our pure talent lying just beneath.

CARE: Do not soak in water. Clear and charge on a bed of herbs like lavender or sage.

TIPS: Carry Lepidolite when you have been feeling down or are being too hard on yourself, to lift your spirits. Place it in the bedroom to create a more tranquil environment, or anywhere in the home where you want to "cool down" the energy.

LIBYAN DESERT GLASS

ORIGIN: Libya

COLOR VARIATION: A clear, pale yellow Tektite from a 26-million-year-old meteoric impact—a blend of both earth and space matter.

ELEMENT: Fire, Spirit

CHAKRA: Solar plexus

QUALITIES: Activation, transformation, balance

HEALING PROPERTIES: While it has a gentler energy than its sister stone, Moldavite (page 191), Libyan Desert Glass carries a vibration that's higher than normal earth mineral frequencies. It is a total energetic system balancer and will help you feel energized and stimulated when you need a boost, and calm and relaxed when it's time to rest. As a stone of transformation, it can be useful when going through major life changes to help you evolve quickly. It also amplifies the stability of the etheric body (see page 7). It is a stone for lightworkers and those who feel a higher calling to provide energetic healing to others.

CARE: Handle this stone gently. Rinse with water. Charge on an altar.

TIPS: You can use this crystal in your most sacred ceremonies. Hold Libyan Desert Glass during guided meditation to call upon higher dimensional guides and tap into the wisdom of the stars. Hold it to your solar plexus and focus on your breath to balance your energy levels.

LITHIUM QUARTZ

ORIGIN: Brazil, North America

COLOR VARIATION: Quartz may have a coating of Lithium on the outside or an inclusion of a Lithium phantom inside that gives it a lavender or pinkish-gray color.

ELEMENT: Air, Spirit

CHAKRA: Third eye, crown

QUALITIES: Calmness, centered-ness, clarity

HEALING PROPERTIES: An anxiety reliever, Lithium Quartz sends calm-ing and soothing vibrations along the nervous system and helps release tension in the body and in the mind. It combats fear and franticness. It is helpful during panic attacks and can be programmed as a stone to help you snap out of a downward spiral. Lithium Quartz assists with breathwork and helps mental focus. It naturally reminds you to return to your center to find your stillness when you feel fear rise up inside you. When used with intention at bedtime, Lithium Quartz can help regulate sleep patterns and break the cycle of insomnia.

CARE: Clear with water. Does not need to be charged.

TIPS: Place Lithium Quartz on your chest pointing down, and take deep breaths in and out to calm the body and deepen relaxation. Place it near your bed to assist with sleep issues. Carry it with you to assist with the release of anxiety, worry, and panic.

MAGNETITE

ORIGIN: The Mediterranean, Australia, North America

COLOR VARIATION: This dark gray or black metallic stone is a naturally occurring eight-sided crystal (octahedron). It is also called Lodestone.

ELEMENT: Earth, Fire

CHAKRA: Root

QUALITIES: Alignment, magnetic attraction, grounding

HEALING PROPERTIES: Naturally attractive, as its name suggests, Magnetite is a drawing stone. It works on the circulatory system, improves the flow of pranic energy (see page 21) throughout the body and helps move toxic energy out of the system. It works well on crystal grids that are intended to magnetically attract things toward you. It also teaches you about your own magnetism and reveals how you attract the same frequency that you radiate out into the world. Magnetite is grounding and helps you keep your head on straight when setting goals, keeping you aligned with what is not only best but also what is realistic and achievable.

CARE: Do not place in water. Clear with Kyanite or Selenite. Charge on a grid or altar.

TIPS: Place five pieces of Magnetite underneath your mattress topper or between your mattress and box spring at the points of the five elemental energy centers: the crown of the head, the throat, the solar plexus, the sacral chakra, and the feet. You can also lay with Magnetite in these locations on your body during a crystal healing.

MALACHITE

ORIGIN: The Congo, Australia, Russia, Zaire

COLOR VARIATION: Light and dark green banding, this stone originally forms as a stalactite.

ELEMENT: Earth, Water

CHAKRA: Heart

QUALITIES: Protection, extraction, growth

HEALING PROPERTIES: By stimulating growth, Malachite can work alongside your intentions to keep things moving forward and protect against delays. It is an amulet for children and travelers and wards off danger. As a copper mineral, it is also a stone of Venus, and, as such, it can be useful in attracting romance into your life. With its layers of growth, Malachite teaches that the best things in life are built up over time and helps you release the need for instant gratification. It also shows us that we need consistency and continued effort for long-term success in both business and love.

CARE: Do not place in water. Malachite can be charged on an altar or by pairing it with Clear Quartz.

TIPS: Place Malachite on your prosperity altar, keep it in your wallet, or attach it to your keychain. Malachite is not a good crystal for placing on the body in crystal healing as its frequency can be disruptive to the circulatory system. It's better used as a talisman instead.

MOLDAVITE

ORIGIN: Bohemia, Czech Republic

COLOR VARIATION: Pitted and translucent deep forest green.

ELEMENT: Spirit, Earth

CHAKRA: Crown, heart, root

QUALITIES: Activation, transformation, initiation

HEALING PROPERTIES: Like other Tektites, Moldavite is a high-frequency crystal that formed from a meteoric impact millions of years ago, which gives it an energy unlike anything else on earth. A favorite among crystal enthusiasts, Moldavite can create a very powerful spiritual awakening. It is a stone that comes to you when you are ready. People who have a hard time fitting into society's norms or expectations can use Moldavite to heal any sense of isolation or judgment from others so that they may recognize their value and fully embrace their own unique selves. It releases unhealthy or outdated programming, whether inherited or learned. It also helps repair karma by showing you patterns so that you can identify, acknowledge, and change them.

CARE: Self-clearing and self-charging, Moldavite is a stone that works best when handled by only one person.

TIPS: Wearing Moldavite can be life changing. It is best to acclimate to it by holding it for just 10 minutes a day and working up to having it on the body for longer periods. It works well when paired with a grounding stone.

MOOKAITE

ORIGIN: Australia

COLOR VARIATION: Mustard yellow, mauve, maroon.

ELEMENT: Earth, Fire

CHAKRA: Root, sacral, solar plexus

QUALITIES: Detoxification, balance, grounding

HEALING PROPERTIES: Also called Mook Jasper, this Australian crystal has its own unique color palette. Its energy is more stimulating than other forms of Jasper. It is useful when starting new endeavors, as it helps you find your footing, build a strong foundation, and stay motivated in the beginning stages. Mookaite helps clarify intentions so that you can be purposeful and attract what you are working toward. It helps you avoid overindulgence and unconscious eating or imbibing. Mookaite deepens your ability to access your instincts, listen to your body, and understand your connection to the earth. It can be useful in connecting to ancestors and past lives through meditation and contemplation.

CARE: Rinse with water. Charge by candlelight.

TIPS: Carry Mookaite when you are beginning to build something. Let it be a touchstone to keep you on track. Wear Mookaite if you want to pay closer attention to what you are putting into your body.

MOONSTONE

ORIGIN: India, Sri Lanka

COLOR VARIATION: Rainbow, peach, green, black, cream, or a combination of colors. Occasionally Moonstone has black or green Tourmaline inclusions.

ELEMENT: Water

CHAKRA: Sacral, heart

QUALITIES: Balance, restoration, calmness

HEALING PROPERTIES: Moonstone is balancing and toning for the emotions, the hormones, and the reproductive system. It can ease the ups and downs caused by Moon cycles and balance out mood swings. Moonstone is a stone of the Goddess and connects you to the Divine Feminine within, showing you how to honor that part of yourself and let it come forward. It can be helpful for deep soul repair and ancestral healing along the maternal line. It is a stone of compassion and grace and resonates with the frequencies of peace and serenity. Moonstone is also good for fertility, pregnancy, and childbirth. Moonstone reminds us that all things in nature are cyclical and deepens our understanding of the importance of all parts of the cycle. Rainbow Moonstone also enhances deep meditation and intuitive development.

CARE: Rinse with water. Charge by the Full Moon.

TIPS: Sleep with Moonstone when your heart is healing. Carry it in your pocket to stay calm. Place it on your sacral chakra to alleviate symptoms of PMS.

NIRVANA QUARTZ

ORIGIN: Himalaya Mountains

COLOR VARIATION: Usually pink, white in rare occurrences.

ELEMENT: Spirit, Water

CHAKRA: Crown, heart

QUALITIES: High frequency, initiation, transformation

HEALING PROPERTIES: A very powerful heart attunement crystal, Nirvana Quartz is a stone of bliss and enlightenment. It raises the vibration of the emotional body and opens the pathways to mystical teachings and their secrets. Nirvana Quartz encourages enduring, multidimensional, unconditional love. It assists with the understanding of Divine Timing and synchronicity, revealing that things happen when they're meant to happen. It can help you become more patient in getting the things you want in life, especially a life partner. It helps you find the love you need right now within yourself and from the sources already around you. It releases feelings of lack and longing and instills centeredness and contentment. Nirvana Quartz can also help you attract spiritual teachers and mentors.

CARE: Handle this stone with care. Self-cleansing. Charge on an altar.

TIPS: When you've been chasing after love or endlessly seeking without finding, build a relationship with Nirvana Quartz. Hold it, meditate with it, carry it with you, and let it bring you back to your own heart center.

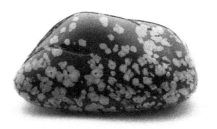

OBSIDIAN

ORIGIN: Throughout the world

COLOR VARIATION: Black, Mahogany, Rainbow, Golden Sheen, Snowflake, and Spiderweb are all naturally occurring varieties. Bright colors like blue, red, yellow, and green are man-made.

ELEMENT: Fire

CHAKRA: Root, solar plexus

QUALITIES: Protection, grounding, strength

HEALING PROPERTIES: A natural volcanic glass, Obsidian is a protective stone that strengthens the aura and leaves you less vulnerable to negative energy. It connects the stabilizing energy of the root chakra with the personal power center of the solar plexus to help you find the resources you need to take action and finish what you start. It is useful for clear and rational decision-making, and helps you choose what is best for your greatest good. It has a long history as a stone for scrying, or crystal gazing (see page 21), and can help you focus your mind and receive visions. Obsidian is also helpful if you need to come out of your shell a bit in order to take the next steps in relationships, either personal or professional.

CARE: Rinse with water. Charge on an altar or charging grid (see page 109).

TIPS: Carry Obsidian into situations you need to move through efficiently. Program it as a protective talisman, and use it as a scrying stone.

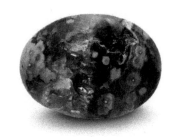

OCEAN JASPER

ORIGIN: Madagascar

COLOR VARIATION: Found in all colors, with round "eyes." While most are opaque, some Ocean Jasper has translucent or crystalized areas. This stone is also called Orbicular Jasper.

ELEMENT: Water

CHAKRA: Corresponds to the color of the stone (see the Chakra Color Guide on page 136).

QUALITIES: Detoxification, protection, clarity

HEALING PROPERTIES: Found at the shoreline, Ocean Jasper is one of the most purifying stones in the crystal kingdom. It can be helpful when you are making healthy changes to your diet or clearing out drugs and alcohol from your system. It also helps release unhealthy belief structures, negative self-talk, anger, resentment, or anything you are looking to wash out of your mind and your being. It's also very helpful for letting go of grudges. Ocean Jasper assists this process by strengthening your desire for health and clarity so that you can feel good about releasing these things that do not serve you. With the grounding aspect of Jasper, it also helps prevent you from falling back into old habits. This is a good stone for empaths.

CARE: Rinse with water. Charge by the Full Moon.

TIPS: Keep Ocean Jasper on you when you are feeling depressed or having a hard time letting go. Place it in your tub during ritual baths.

OPAL

ORIGIN: Australia, Mexico, South America, Ethiopia, Mali

COLOR VARIATION: Fire and Boulder are varieties. The possible colors include blue, green, pink, white, and black.

ELEMENT: Spirit, Water, Fire

CHAKRA: All

QUALITIES: Activation, protection, comfort

HEALING PROPERTIES: As stones of the Water element, Opals teach us how to be receptive and can be useful for deep meditation and inner exploration. For people who take a long time to relax into a meditation, these stones can facilitate that process more quickly and help you "drop in." Opals are emotional body healers and can help you root out the thorns of abuse or betrayal that may hold you back from trusting others or allowing yourself to be vulnerable. The stones honor one's inner beauty and are helpful when you need to remember your inner light. They connect you to your inner Divine self and can facilitate connection to spirit guides and angelic beings.

CARE: Rinse with water. Charge by the Full Moon.

TIPS: Place Opal on your Full Moon or New Moon altar when setting intentions during these phases in the monthly cycle. Place Opal on your heart or third eye when meditating to achieve theta state (the brain wave state of deep meditation) faster and easier.

OPTICAL CALCITE

ORIGIN: Throughout the world

COLOR VARIATION: Gold, pink, and clear rhombus–shaped crystals. This stone is also called Iceland Spar.

ELEMENT: Air, Water

CHAKRA: Corresponds to the color of the stone (see the Chakra Color Guide on page 136)

QUALITIES: Revitalization, restoration, navigation

HEALING PROPERTIES: It can help open the windows to the self, making Optical Calcite a stone of discovery, exploration, and epiphany. It can guide you to things within yourself that you may have lost, such as passion for activities that you used to love, or dreams and goals that you may have forgotten. It can also help you uncover things about yourself that you never realized and lead you to answers about why you are the way you are. This can reveal root causes and launch the process of repairing and rebalancing. Optical Calcite is useful in the shamanic process of soul retrieval (see page 169), where we draw back the lost parts of ourselves to return to wholeness. It is also a stone of navigation and has a long history of use by seagoers and explorers to find their ways.

CARE: Rinse with water. Charge by candlelight.

TIPS: To reclaim or reignite lost or dormant parts of yourself, place Optical Calcite upon your heart, solar plexus, or third eye while lying down. Imagine sending your awareness into and through the stone.

PEACOCK ORE

ORIGIN: Throughout the world

COLOR VARIATION: Blue, purple, and gold on a matrix (see page 21). This name is used for both Bornite and Chalcopyrite, which are slightly different minerals.

ELEMENT: Fire

CHAKRA: Third eye, throat, solar plexus

QUALITIES: Activation, protection, magnetic attraction

HEALING PROPERTIES: A stone of joy and happiness, Peacock Ore shimmers with rainbow flashes. The peacock is associated with Lakshmi, a prosperity goddess. As a totem, the peacock has a history of association with awakening, visions, and signs from the universe. Peacock Ore brings positive energy into the home and brightens any room it's in. As it connects the throat and solar plexus, it is helpful with self-expression, public speaking, and presentations. Peacock Ore is stimulating to the third eye and can help with visioning, astral travel, and guided meditation. It helps you translate visions into actual information that you can then apply to your life.

CARE: Do not place in water. Clear with sage. Charge with sunlight.

TIPS: Place Peacock Ore on the third eye to awaken powerful visioning and open the mind to new possibilities. Place it anywhere in your home that you want to create a happier atmosphere.

PERIDOT

ORIGIN: Hawaii, Pakistan, India, China, Norway, Antarctica

COLOR VARIATION: This olive-green stone is also called Olivine.

ELEMENT: Fire

CHAKRA: Heart, solar plexus

QUALITIES: Balance, elevation, focus

HEALING PROPERTIES: Peridot is a personal power crystal because the frequency of the stone helps simplify questions and ideas that feel complicated. It teaches you to turn your focus inward instead of outward, helping you realize your purpose here on earth. The prosperity and success you're seeking will follow once you're aligned with your inner purpose. Peridot is a stone that helps you embrace change, even when it is forced or emotionally difficult. It can help anchor your resolve and convictions. Peridot reminds you that what you've been through does not define you and that you can grow beyond your past.

CARE: Rinse with water. Charge on an altar.

TIPS: Wear Peridot when you are shifting out of old ways and looking to attract new opportunities. Carry it as a heart healer when dealing with breakups.

PHANTOM QUARTZ

ORIGIN: Throughout the world

COLOR VARIATION: Clear Quartz with mineral inclusions.

ELEMENT: Spirit, Earth

CHAKRA: Crown, root

QUALITIES: Revelation, transformation, activation

HEALING PROPERTIES: Phantom Quartz is like a little time capsule that helps you look at the phases of your own life. This stone is useful for acknowledging the milestones and growth you've achieved, which in turn can help you remember what has and hasn't worked for you in the past. Phantom Quartz can help you heal your past by recognizing the strength you've gained by overcoming challenges. It also helps uncover patterns and encourages letting go of those that don't serve you. Phantom Quartz can also be used for past-life work and sending healing back to former incarnations of yourself.

CARE: Rinse with water. Charge on an altar.

TIPS: While gazing into a Phantom Quartz, begin a meditation where you allow yourself to travel back in time and remember moments in your life when you leveled up. Place the stone under your pillow and ask for a vision of a past life that needs healing. Carry the stone as a reminder that growth begins within.

PIETERSITE

ORIGIN: South Africa

COLOR VARIATION: A relative of Tiger's Eye (see page 232), this stone can be indigo, purple, and brown.

ELEMENT: Air, Earth

CHAKRA: Third eye, root

QUALITIES: Activation, transformation, grounding

HEALING PROPERTIES: Pietersite is unique in that it both opens the third eye while activating inner sight, and grounds you to help you apply logic at the same time. It balances the hemispheres of the brain and is perfect for activities where you need to use both parts together. A good example is divination, when you need to see and interpret symbols, visions, and messages and clearly translate these messages to another person.

Pietersite is invaluable for tarot readers, oracles, clairvoyants, and all who practice divinatory modalities. Pietersite also helps you retain information and is helpful for students, trainees, and anyone who is learning a lot at once.

CARE: Use sage or a tree resin incense like copal or frankincense to clear (either stick, cone, or loose incense). Charge with the Sun.

TIPS: Place a piece of Pietersite on top of your tarot or oracle cards before wrapping them with a scarf. Hold the bundle in your receptive hand as you sit in a meditative state and imagine your third eye opening and information entering, passing down through the chakra system and anchoring into the earth.

POLYCHROME JASPER

ORIGIN: Madagascar

COLOR VARIATION: Multicolored pastel and earth tones.

ELEMENT: Earth

CHAKRA: All

QUALITIES: Inspiration, creativity, grounding

HEALING PROPERTIES: This stone is a storyteller. It often contains gray-blue patterns against reds, pinks, and oranges, invoking the combination of the sky and the earth. They are stones of the imagination and connect you to your creative channels. Polychrome Jasper assists with problem-solving, creative solutions, and finding shortcuts. In awkward social settings, it can help you break the ice. Polychrome Jasper is also one of the best crystals for accessing past-life information. Its energy can be very transportive and can bring you back to a long-forgotten memory of a former incarnation that is locked away in your soul's DNA.

CARE: Rinse with water. Charge with sunlight.

TIPS: Find a horizon line on your Polychrome Jasper and project yourself into the stone. Go exploring and see what it reveals. For past life exploration, place the stone between your feet while lying down, count back from 10 to 1 to put yourself into theta state (deep meditation), and allow an image to arise.

PRASIOLITE

ORIGIN: Poland, the United Kingdom, Brazil, Africa

COLOR VARIATION: This pale green stone is usually seen with a chevron pattern. It is also called Green Amethyst.

ELEMENT: Air

CHAKRA: Heart, third eye, crown

QUALITIES: Activation, calmness, balance

HEALING PROPERTIES: Prasiolite allows you to handle even the most stressful of tasks with grace, as it radiates a calm, peaceful, and regal energy. It keeps you coolheaded when you are called upon to lead or direct, and allows decisions to be made from a place of both rational and empathic justice. It teaches that leadership does not mean controlling others, but helping others develop and apply their strengths and guiding them toward opportunities to use them. Prasiolite is also a highly spiritual stone and creates a powerful heart-crown connection. It is a crystal for yogis, lightworkers, and energy healers to keep their connection to Source clear and free from ego.

CARE: Rinse with water. Charge with moonlight or on an altar.

TIPS: Carry or wear Prasiolite when you are taking the reins of a situation. Place it in your meditation space to open higher channels of Divine grace. Hold it to the third eye before performing healing work to gain greater insight into the root cause of symptoms.

PREHNITE

ORIGIN: Mali, South Africa, Mexico

COLOR VARIATION: This light yellow-green stone often has dark green inclusions of Epidote.

ELEMENT: Water, Fire

CHAKRA: Heart, solar plexus

QUALITIES: Restoration, balance, energy

HEALING PROPERTIES: A stone to heal the healer, Prehnite encourages self-love and self-care while restoring balance to those who often support the well-being of others. Like Peridot, this stone links the heart to the solar plexus to encourage belief in yourself and your purpose. Prehnite boosts and restores energy levels when you feel drained, without being overly stimulating. It resonates with the properties of courage and confidence and releases insecurity or self-doubt. Prehnite is also good to have in the home, as it creates a calm and healing atmosphere. It helps speed recovery time, especially from verbal or emotional abuse, because it brings the focus back to the true self rather than the negative statements or actions of another. Prehnite aligns you with energies of abundance and prosperity. Crystals with Epidote will have the same properties, only amplified.

CARE: Rinse with water. Charge on an altar or charging grid (see page 109).

TIPS: Place Prehnite in your meditation space. Carry it with you when you need a boost of energy or encouragement.

PYRITE

ORIGIN: Noth America, Africa, Spain, Peru, Italy

COLOR VARIATION: Naturally forms in cubes, clusters, and sun discs. Also called Fool's Gold.

ELEMENT: Fire

CHAKRA: Solar plexus

QUALITIES: Strength, protection, radiance

HEALING PROPERTIES: Pyrite holds the ancient wisdom of the solar deities Apollo, Ra, and Aten. It helps us remember our courage, strength, and radiance, to shine the lantern of our truth, to polish the jewel within. Pyrite protection is wielded as the warrior's shield and the purifying and transmuting rays of the Sun. It encourages us when we are bored and unmotivated. Although not true gold, this stone is still valued by the alchemist. It reminds us that treasures may tarnish, but this is not decay—it's simply a patina. Pyrite comes from the root *Pyr*, Greek for "fire." As such, it corresponds to the etheric body.

CARE: Do not soak in water. Cleanse and charge with sunlight.

TIPS: Hold Pyrite at your core to help you when you need to balance your ego. Carry it with you to feel coura-geous and shine with your own power and strength. Place Pyrite in the center of a crystal grid for drawing in prosperity.

RHODOCHROSITE

ORIGIN: Argentina, India, South Africa, Germany

COLOR VARIATION: Forms as stalactites, banded light and bright pink.

ELEMENT: Water

CHAKRA: Heart, solar plexus, sacral

QUALITIES: Activation, self-love, centeredness

HEALING PROPERTIES: Romance, bonding with others, or heart sharing always starts with a well-cultivated love of the self, and Rhodochrosite can be an important ally for this. It strengthens the pathway between will and desire, and stokes the sacred fire within the temple of the heart. It is a crystal of self-forgiveness and releases self-judgment and harsh self-criticism, replacing negative self-images with supportive and encouraging thoughts. It helps release guilt, shame, and embarrassment, especially when those things were unfairly enforced at a formative age, whether through bullies, religious institutions, or disciplinary figures. Rhodochrosite helps you regroup after a setback, and get back on the horse when you fall off.

CARE: Keep it on a small dish of dried flowers, like lavender or rose petals, to keep it both cleared and charged.

TIPS: Hold Rhodochrosite to your heart and breathe deeply to restore your sense of well-being. Wear it on a necklace and share this energy with others, as Rhodochrosite is one of the most radiant of the heart stones.

RHODONITE

ORIGIN: Madagascar, Brazil, Australia, Peru

COLOR VARIATION: Pink and black.

ELEMENT: Water, Earth

CHAKRA: Heart, root

QUALITIES: Protection, calmness, grounding

HEALING PROPERTIES: When it comes to feelings, more is not always better. When your heart is racing, the butterflies in your stomach are buzzing, or you are generally over-feeling, Rhodonite steps in to take some of the extra emotions off your plate and grounds that energy so that you can maintain balance and serenity. It helps you be patient with others and yourself and not rush relationships. As a protective crystal, Rhodonite also helps you establish your boundaries and not be overly accommodating or too quick to say yes. It helps you stay true to yourself and maintain a sense of discretion if you find yourself revealing too much too soon.

CARE: Rinse with water or smudge. Charge on an altar or by candlelight.

TIPS: Take Rhodonite with you to bed at the end of an emotionally taxing day. Carry it with you to calm your nerves if you are going somewhere that will cause you to feel overwhelmed. Wear Rhodonite if you find yourself needing a bit more of a filter around others.

RHYOLITE

ORIGIN: India, Australia, the United States, Slovakia

COLOR VARIATION: Birdseye, Rainforest, Galaxy.

ELEMENT: Fire

CHAKRA: Corresponds to the color of the stone (see the Chakra Color Guide on page 136)

QUALITIES: Stimulation, transformation, harmony

HEALING PROPERTIES: Rhyolite is a stone of cooperation and mediation, and serves as a conduit between disharmonic entities. When it is required for people to set aside their differences, find common ground, or come together to accomplish something, Rhyolite bridges the gap. While it is great for teamwork, Rhyolite also serves to bridge aspects within the individual and can encourage conflicting behavioral qualities to work in harmony. It is a healing stone for those who are going through an identity crisis. It's also useful when transitioning into a new career, moving to a new region, or undergoing other major life events. Rhyolite is a good stone if you're looking to work with holistic methods and modalities.

CARE: Cleanse and charge with sunlight for 20 minutes between sunrise and noon.

TIPS: Carry Rhyolite with you when you are entering a situation where there might be conflict of personalities, beliefs, or opinions. When there is turbulence in the family, workplace, or social circle, make sure you keep this stone close at hand.

ROSE QUARTZ

ORIGIN: Madagascar, South Africa, Namibia, the United States, Brazil

COLOR VARIATION: This stone can be found raw or tumbled with colors ranging from pale to bright pink. This stone is very rarely found with natural terminations.

ELEMENT: Water

CHAKRA: Heart

QUALITIES: Compassion, calmness, love

HEALING PROPERTIES: This is the stone of unconditional love in its many permutations: self, romantic, family, and fellowship. Rose Quartz is one of the five elemental Quartz, along with Clear Quartz, Amethyst, Citrine, and Smoky Quartz. When used together, these five stones create a powerful healing grid that can be used on the body for harmonizing all the subtle bodies. It helps recovery after any difficult emotional experience and is especially comforting during periods of depression or grieving. Rose Quartz teaches compassion and lets us connect more easily with others. It takes away the need to try and simply allows an openness that lets understanding flow. It is a stone for healers, lovers, children, and mothers.

CARE: Rinse with water. Charge with moonlight. Pair with Selenite for extra amplification.

TIPS: Hold this stone up to any chakra to dissolve hate, anger, jealousy, or despair. Rose Quartz makes a good gift and can be programmed by holding it to the heart and envisioning a blessing for the recipient being infused into the crystal.

RUBY

ORIGIN: India

COLOR VARIATION: This red stone is also called Corundum. If it has a star effect, it is called Star Ruby.

ELEMENT: Fire

CHAKRA: Heart, root

QUALITIES: Initiation, stimulation, guidance

HEALING PROPERTIES: Rubies awaken your instincts and connect you to ancient wisdom, sacred geometry, and dramatic arts. Raw Rubies grow in the shape of a hexagram and often have raised triangular shapes that look like pyramids. These are known as record-keeper crystals. Rubbing your thumb across the triangle, you can access its guidance. Rubies help you walk the walk and stand by your word. This stone encourages you to be loving but also practical. Ruby helps defragment the heart and emotional body, making space for everything to breathe. You can receive more healthy energy when there aren't scattered fragments within you.

CARE: Rubies can be cleared and charged on a small plate of loose herbs or dried flowers.

TIPS: Carry a raw Ruby in your pocket, wallet, or purse to serve as a reminder to uphold your word and follow through on your end of agreements. If you have three Rubies, you can place them in a triangle pattern around your heart center to charge and empower this chakra.

RUTILATED QUARTZ

ORIGIN: Throughout the world, primarily in Brazil

COLOR VARIATION: Thin gold or reddish threads of Rutile can occur as inclusions in Clear or Smoky Quartz.

ELEMENT: Spirit, Fire

CHAKRA: Crown, solar plexus

QUALITIES: Invigoration, energy, clarity

HEALING PROPERTIES: Rutilated Quartz acts like a little battery, bringing energy and electricity to your intentions. It is useful for clearing away distractions and interference, either from people around you or from subtler realms. It raises energy levels and helps you access the reserves needed to make it to the finish line. It will also raise the vibrations of your other stones. It amplifies crystal grids and makes candle magic more powerful. Rutilated Quartz can serve as a transmitter and a receiver to broadcast messages out into the world, especially when these messages are in alignment with the Divine Will. Rutile is said to be the "golden hair of Venus," and, as such, it invokes beauty, love, and fecundity.

CARE: Rinse with water. Charge on an altar.

TIPS: Wear or carry Rutilated Quartz at work if you find yourself being micromanaged. Place it on your bedside table, and make it the first thing you reach for in the morning as a wake-up ritual in order to warm up your body's engine.

SARDONYX

ORIGIN: India, Germany, Czech Republic, Brazil, Uruguay

COLOR VARIATION: Agate with reddish or black and white bands of Sard and Onyx.

ELEMENT: Earth

CHAKRA: Crown, root

QUALITIES: Protection, unity, grounding

HEALING PROPERTIES: Sardonyx is a stone that represents the Hermetic axiom, "As above, so below." It is light and dark, transparent and opaque. It blends two minerals, and it is good for bringing diverse groups together to share a common goal. It teaches you how to have both better sight and better insight, allowing aspects to stand out against whatever they contrast. Sardonyx reminds us that light is ever present, even in seeming darkness, giving the stone the frequency of optimism. It creates a background that lets your mind's eye bring forward a vision, making it a good stone for crystal gazing or scrying (see page 21). Sardonyx is protective and sometimes carved into eye shapes as protective amulets to ward off evil.

CARE: Rinse with water. Charge on an altar.

TIPS: When you need to focus and get work done, hold Sardonyx in your lap. Place it before you on a table as you go into a meditative state for scrying.

SCOLECITE

ORIGIN: India, Australia, the Himalaya Mountains

COLOR VARIATION: White and very rarely pink. Usually found as tumbled or polished stones. The raw version forms long, thin crystals.

ELEMENT: Spirit

CHAKRA: Crown

QUALITIES: Attunement, elevation, inspiration

HEALING PROPERTIES: This is a stone for activating our highest connections, since Scolecite's many rays shine from a higher perspective over the context of our lives. It serves to remind you of the things you've gotten through, the dangers you've escaped, and the miracles you have witnessed. It reveals the cosmic plan that's guiding us toward a better way of being and reminds us not to worry about the little things. The stone encourages you to reclaim the power you may have given away to minor frustrations and instead put your faith in something higher. It connects us more deeply to the Source, Divine Wisdom, and omniscient understanding.

CARE: Rinse in water. Charge by the Full Moon.

TIPS: Place Scolecite above the crown when lying down to open the Spirit center and help you connect to your higher awareness. You can also place Scolecite in your meditation space to bring in white light frequencies.

SELENITE

ORIGIN: Mexico, Morocco, Madagascar, Russia

COLOR VARIATION: This stone is usually white and more rarely peach. It can be found as wands, towers, palm stones, slabs, and carved shapes. It's also called Gypsum.

ELEMENT: Spirit

CHAKRA: Crown

QUALITIES: Alignment, amplification, clarity

HEALING PROPERTIES: Uplifting, clearing, and a tonic to the aura, Selenite looks like crystalized white light. It's named for the Goddess of the Moon, Selene. Like the Moon, it does not create its own light, but rather reflects and amplifies light. When you can't see through the fog, Selenite directs your awareness upward. Like a mountain peak it reminds you to keep cool and rise above the cloud cover, finding peace in space and distance. Selenite improves sleep when placed by your bed. It can also improve your posture by opening the channel of energy from the root chakra to the base of the skull. It is healing for the bones, teeth, and spine.

CARE: Do not place in water. Self-cleansing.

TIP: Pass a Selenite wand over your aura, just a few inches over the surface of the skin, to clear your energetic lint trap. Lay a Selenite wand vertically on your back or front while lying down to align your chakras and send healing pranic energy (see page 21) through the spinal column.

SEPTARIAN

ORIGIN: India, Madagascar, Morocco

COLOR VARIATION: Yellow Calcite and brown Aragonite in a Limestone matrix (see page 21).

ELEMENT: Fire, Earth

CHAKRA: Solar plexus, sacral, root

QUALITIES: Support, extraction, grounding

HEALING PROPERTIES: Since Septarian builds patience and tolerance, it is used to balance the three lower chakras. It grounds you into reality and heightens your awareness of how you're performing. It teaches accountability and integrity and encourages you to be honest about whether you are doing a job to the fullest capacity. It also discourages and deprograms codependent tendencies. Septarian teaches you to take care of yourself first and to set boundaries with anyone who takes you for granted.

CARE: Rinse with water. Charge with 20 minutes of sunlight.

TIPS: Keep Septarian with you when you are evaluating your work, especially when editing or making finishing touches. Carry Septarian when you feel like you are carrying the weight of other people's issues, to help you release them and keep your focus on your own path.

SERAPHINITE

ORIGIN: Eastern Siberia

COLOR VARIATION: Deep forest-green with silver feathery winglike patterns.

ELEMENT: Fire

CHAKRA: Heart, crown

QUALITIES: High frequency, elevation, connection

HEALING PROPERTIES: Drawing its name from the holy order of angels known as the Seraphim, evocative Seraphinite aids contact with angels and beings of higher realms, including Divine Feminine energies. It opens not only the crown but also the higher chakras that reside above the physical body, allowing for an even higher expression of the heart temple. This can clear out anything that's holding you back from your spiritual growth. When paired with Charoite, Seraphinite can help you develop your clairvoyance and clairaudience—or clear seeing and clear hearing. If you practice astral travel or have out-of-body experiences, Seraphinite is a good crystal to help you do this safely and integrate more easily back into your physical body. It also connects deeply with the nature realm and fairy energy.

CARE: Keep away from water and smoke. Clear Seraphinite with Selenite or by candlelight. Charge on an altar.

TIPS: Hold it in your hand during deep meditation to let go even more and come back more easily. Place the crystal on the heart center while practicing breathwork to expand your lung capacity.

SERPENTINE

ORIGIN: Throughout the world

COLOR VARIATION: Deep olive to lime green. This stone is also called New Jade.

ELEMENT: Fire

CHAKRA: Heart, solar plexus

QUALITIES: Activation, initiation, energy

HEALING PROPERTIES: Serpentine activates the Kundalini energy, also known as the Serpent Fire, which is coiled in the root chakra until it is awakened and rises upward. This rising can initiate a spiritual awakening and bring a deeper awareness of how energy moves throughout the body and how you can direct that energy. Serpentine removes energy blockages and knots throughout the entire system. It brings creativity to the surface to give emotional energy a healthy outlet. Serpentine teaches you how to move like a wave, which can be helpful in moving forward in life when the straight and narrow is ineffective.

CARE: Rinse in water. Charge on a grid or altar.

TIPS: Place Serpentine on any chakra you'd like to draw your Kundalini energy up to. Place it near plants or in a garden to encourage growth. Place it in your meditation space to raise the vibration there.

SHIVA LINGAM

ORIGIN: Narmada River in Western India

COLOR VARIATION: Oval- or egg-shaped stones with patterns of brown, reddish brown, and beige.

ELEMENT: Fire, Water

CHAKRA: All

QUALITIES: Unity, stimulation, fertility

HEALING PROPERTIES: Holding the energy of one of the holiest sites in India, Shiva Lingam represents the cosmic egg from which all of creation was born. In the microcosm, it represents the auric egg, the energetic field around your body. Shiva Lingam holds both the concepts of unity and duality, teaching that all individuals are a part of a unified whole. The stones are a blending of male and female energy and can be both stimulating or calming depending on how they are used. Placed upon an altar, they can be helpful in anchoring your intentions and drawing assistance from the universe. It is considered one of the best stones for fertility and is healing for the sacral chakra.

CARE: Rinse with water. Charge with sunlight.

TIPS: Gift the stone to couples or individuals who are trying to conceive. Carry Shiva Lingam when doors are opening to better understand your purpose and be of service to the world.

SHUNGITE

ORIGIN: Lake Onega in Karelia, Russia

COLOR VARIATION: Raw Shungite is matte black and powdery like carbon. Noble Shungite is the high-grade stable version and is silvery metallic.

ELEMENT: Earth

CHAKRA: Root

QUALITIES: Purification, protection, grounding

HEALING PROPERTIES: Completely clearing on all levels, Shungite will strip away the layers of auric buildup that can come with living in a densely populated area. It is very protective against environmental toxins, pollutants in air and water, and especially against people who want to suck your energy. It not only helps keep toxic people away but also allows you to clear their energies faster. With blocks released and negativity at bay, Shungite then completes the process by helping you recharge after any type of work or interaction that has left you feeling depleted.

CARE: Rinse with water. Charge with sunlight. Shungite can be left in the sun for an entire day to maximize its benefits.

TIPS: Place a piece of Shungite in your water bottle to reap its purifying effects. Place a few pieces in a bath for aura clearing. Wear Shungite to keep psychic vampires away.

SMOKY QUARTZ

ORIGIN: Throughout the world

COLOR VARIATION: Deep, almost-black gray to pale gray.

ELEMENT: Earth

CHAKRA: Root

QUALITIES: Extraction, protection, grounding

HEALING PROPERTIES: Smoky Quartz can be revealing and help you find answers to life's difficult questions. It prepares you to hear the truth and puts you in a place of foundational security so you can weather any storm. Smoky Quartz will open you up where you didn't even realize you were blocked. It's one of the best crystals to use for shadow work, when we need to face and embrace the imperfect human parts of ourselves. These stones teach us to resist becoming overly attached to ideas or material things and to release when objects start to control us or when something wants to break us.

CARE: Rinse with water. Charge on an altar.

TIPS: Pair Smoky Quartz with Clear Quartz as an energetic duo and hold one in each hand during meditation to move energy back and forth. This will simultaneously clear negative energy out and let light in.

SNAKESKIN AGATE

ORIGIN: Oregon

COLOR VARIATION: Gray-and-white patterning that's partially translucent and looks like a snake's skin.

ELEMENT: Fire, Earth

CHAKRA: Solar plexus, root

QUALITIES: Transmutation, adventure, clarity

HEALING PROPERTIES: A stone of shamanic journeying and deep transformation, Snakeskin Agate helps you shed the old and initiate a rebirth. When your self-image has become too constrictive and you want more freedom to evolve, this crystal can help you release your self-imposed labels and make room for the real you. Snakeskin Agate helps those who tend to hesitate too long when faced with new opportunities and can motivate you to act so you don't miss your chance. This stone awakens a sense of adventure and can help you look fear in the eye and embrace it rather than shoo it away.

CARE: Rinse with water. Charge by candlelight.

TIPS: Carry or wear Snakeskin Agate when going through big life changes, especially if you are having a hard time letting go of your old ways.

SODALITE

ORIGIN: Brazil, India, China

COLOR VARIATION: Indigo blue with white marbling. When the stone has orange Feldspar inclusions, it is called Sunset Sodalite.

ELEMENT: Air

CHAKRA: Throat, crown

QUALITIES: Detoxification, pain relief, perception

HEALING PROPERTIES: Sodalite deepens our ability to communicate with and hear messages from the universe. It is helpful for quitting smoking and can also break up unhealthy mental fixations. One of its most important qualities is that it is a fear banisher, especially when fear stems from worry about what others are doing, thinking, or feeling. It leads to clear perception, which lets the mind open to higher thinking rather than going in circles worrying. Sodalite's power to dissolve fear leads to growth in both self-expression and creativity.

CARE: Rinse with water. Charge with moonlight.

TIPS: Place Sodalite at your knees when you are feeling weakness or pain there. Carry or wear it when you want to speak from your highest truth.

STAUROLITE

ORIGIN: Switzerland, Russia, Australia, Brazil, the United States

COLOR VARIATION: This stone features naturally formed opaque brown crystal crosses in a silvery matrix (see page 21). These stones are also called Fairy Crosses.

ELEMENT: Earth

CHAKRA: Root, crown

QUALITIES: Protection, navigation, decisiveness

HEALING PROPERTIES: Fairy Crosses evoke a magical implement from medieval times: the equal-armed cross of the four cardinal directions. This makes them a natural compass and talisman for finding your way, especially when you're at a crossroads. They attune your sense of direction and help with decision-making. They are also powerful crystals for Earth conservation and environmental healing. Staurolite are protective as the cross can be used to banish negativity.

CARE: Do not place in water. Clear and charge on a Selenite wand or charging grid (see page 109).

TIPS: Place Staurolite on your third eye during meditation when you are looking for a vision of which direction you should go, or when you have multiple options on your plate and are unsure which to choose. You can also write options on a piece of paper and use Staurolite as a divination tool by tossing it on the paper and seeing where it lands. The X will mark the spot.

STILBITE

ORIGIN: India, the Himalaya Mountains

COLOR VARIATION: Can be polished or raw, peach Stilbite often grows with clear Apophyllite.

ELEMENT: Spirit

CHAKRA: Sacral

QUALITIES: Stability, healing, compassion

HEALING PROPERTIES: Stilbite's energy is soft yet powerfully Divine; it's like holding a piece of heaven in your hand. The stone has a rich smoothness that melts into the cracks of the soul, heals the heart, and bestows the energies of grace and compassion. Stilbite is encouraging and reassuring, but not pushy, like a superior who never yells at you. It assists with the gentle awakening of your creative capacity and encourages you to try your hand at artistic endeavors. It helps release shyness and insecurity. It clears away anxiety—especially that which stems from fear of judgment from others. Stilbite is helpful when processing emotions and can help you channel your feelings and move them out of your body rather than feeling like you are sitting in emotional soup.

CARE: Rinse with water but do not soak. Charge with moonlight.

TIPS: Carry Stilbite in your pocket when you need to go into a potentially uncomfortable situation. If you feel anxiety creeping in, rub the stone between your fingers to calm yourself down and remind yourself that you are in control of your reactions.

SUGILITE

ORIGIN: Canada, South Africa, Italy, Australia, India

COLOR VARIATION: Deep purple, often occurring with the minerals Bustamite and Richterite.

ELEMENT: Air, Fire

CHAKRA: Third eye

QUALITIES: Activation, high frequency, purification

HEALING PROPERTIES: Sugilite is known to embody the energy of the Violet Flame, a purifying frequency that clears away debris from the etheric body (see page 7) and transmutes negative energy. It can be used in cord-cutting to free you from ties to the past. It is a stone of mysticism and magic and can amplify clairvoyance and psychic visions. Sugilite can be used to facilitate communication with high-vibrational spirit guides. It deepens meditation and brings visions clearly into the mind's eye. Although it is a high-frequency crystal, Sugilite does have a grounding property and can help you stay focused during meditation if you find yourself falling asleep or drifting out of your body.

CARE: Clear with water or Reiki. Charge on an altar.

TIPS: Hold Sugilite as you call upon the Violet Flame of Saint Germain, visualizing purifying fire encompassing your aura. Hold it to your third eye chakra to activate spiritual awakening.

SUNSTONE

ORIGIN: Oregon, India, Tanzania, Australia

COLOR VARIATION: Clear to opaque with copper inclusions.

ELEMENT: Fire

CHAKRA: Sacral, solar plexus

QUALITIES: Activation, amplification, illumination

HEALING PROPERTIES: Like its name suggests, Sunstone generates radiance as its inclusions of copper sparkle within. It is a confidence booster and helps with motivation and amplifying energy levels. It also attracts prosperity and opportunity. Sunstone can also be useful for those who find themselves to be naïve or easily fooled. If there is anything lurking in the shadows, or you are living in a fantasy land, Sunstone will throw a beam of illumination on all that is about you. It clears away masks and veils and lets inner beauty shine. It helps you identify your true motivations and better understand the motivations of others. Sunstone can reveal the next step on your path when you're not sure how to proceed.

CARE: Clear and charge with sunlight.

TIPS: Meditate with Sunstone to see through any ambiguity. Carry Sunstone into situations where you want to make sure you are being seen and listened to.

SUPER SEVEN

ORIGIN: Brazil

COLOR VARIATION: Also called Melody's Stone, this crystal is a combination of Amethyst, Clear Quartz, Smoky Quartz, Cacoxenite, Rutile, Geothite, and Lepidocrocite.

ELEMENT: All

CHAKRA: All

QUALITIES: Activation, transformation, connection

HEALING PROPERTIES: A powerful combination of seven different minerals, Super Seven is a full chakra system activator. The sevenfold nature of the world is seen in the classical planets, the days of the week, the directions, the colors in the rainbow, and the notes of the musical scale (just to name a few), making this an important talismanic crystal for magical practitioners. Super Seven helps in healing each seven-year phase of your life. Super Seven can remind you of the many lessons learned, the many steps taken, and the many doors that opened to bring you to this exact point in time.

CARE: Self-cleansing and self-charging, it is best to not let others handle your Super Seven.

TIPS: Program a Super Seven to help you achieve your long-term goals. Place it on your altar to amplify your prayers and intentions. Meditate with Super Seven to activate all of your senses, both physical and metaphysical.

TANGERINE QUARTZ

ORIGIN: China, Brazil, Africa, Madagascar

COLOR VARIATION: Deep red to orange. Clear Quartz with an iron-oxide coating or phantom.

ELEMENT: Earth

CHAKRA: Sacral

QUALITIES: Stability, activation, detoxification

HEALING PROPERTIES: Like an experienced soldier ready to go to battle for you, Tangerine Quartz obliterates energy blocks that keep you from manifesting your intentions. It draws high-frequency clearing down into the body through the sacral chakra and toward the earth to root out any weeds. It helps draw out old toxic energies that we've stored like luggage in the closets of the past. Tangerine Quartz has an ancient energy. It connects you to Earth magic, nature teachings, and helps you draw stability from the earth. With this stability you can be more present and self-aware. It also helps you listen to your body, know what you need, and act on that knowledge.

CARE: Do not place in water. Clear with palo santo. Charge with sunlight.

TIPS: Place Tangerine Quartz below the navel pointing down. Breathe deeply and visualize light moving in through the crown and out of your feet. Meditate with Tangerine Quartz to tune into your body's awareness.

TANZANITE

ORIGIN: Tanzania, South Africa, India

COLOR VARIATION: Deep purple to blue-purple.

ELEMENT: Air, Spirit

CHAKRA: Third eye, crown

QUALITIES: Activation, empowerment, revelation

HEALING PROPERTIES: Tanzanite helps you listen clearly and speak your truth. With this stone, your thoughts and words will be informed by your higher self instead of by the opinions, fears, and limited views of others. It strengthens your ability to listen, share, observe, and ask the things that are most useful, keeping the mind away from pettiness, drama, and useless information. Tanzanite reminds us that wisdom and understanding grow through the conscious interactions of the day, not through the mindless repetitions of work. It teaches you to make conscious choices rather than operate on autopilot, and centers you when you feel off-balance. A crystal of devotion and high-frequency awareness, Tanzanite opens the channels to paths of enlightenment and encourages spiritual evolution.

CARE: Keep out of sunlight. Clear with water. Charge by the Full Moon.

TIPS: Bring Tanzanite with you into deep conversations or discussions about abstract concepts. Keep it in your meditation space to open channels to higher guidance.

TEKTITE

ORIGIN: Australia, North America, Africa, China, Brazil

COLOR VARIATION: Ranges from opaque to translucent black. Also see Moldavite (page 191) and Libyan Desert Glass (page 187).

ELEMENT: Fire, Air

CHAKRA: All

QUALITIES: Activation, connection, transformation

HEALING PROPERTIES: Formed from the terrestrial debris of ancient meteorite impacts, Tektites have a unique cosmic vibration that comes from the realm of the stars and connects you to things beyond the material, earth-bound plane. The stones can be used for astral travel, exploring other dimensions during meditation and dreaming, and as powerful talismans for breakthroughs and epiphanies. They are consciousness-expanding and useful for bridging the gap between what is established as fact and what you believe to be possible. Traditionally, Tektite has been used as a stone of good luck and protection. It can assist with deflecting negative entities, especially when you are off the beaten path.

CARE: Rinse with water. Pair with Citrine for charging and amplification.

TIPS: Wear or carry Tektite to attract others who are on a path of spiritual advancement, especially when you are feeling alone on your journey. Use Tektite as a talisman to deepen your intuition.

TIGER'S EYE

ORIGIN: Brazil, North America, South Africa, India

COLOR VARIATION: Gold, red, or blue (also known as Falcon's Eye, page 171). When banded with Hematite and Red Jasper, this stone is called Tiger Iron.

ELEMENT: Fire, Earth

CHAKRA: All

QUALITIES: Transformation, empowerment, grounding

HEALING PROPERTIES: This mineral originates as Asbestos, which over time is replaced by Quartz, until it becomes Tiger's Eye. A stone of transmutation, it changes from a toxic, fibrous substance into a stable, crystallized solid, literally turning itself gold. A crystal of courage, warmth, leadership, and conviction, Tiger's Eye assists you in bringing your best qualities forward and inspiring others to do the same. As it centers you in sureness and security, Tiger's Eye lets you freely and openly convey your thoughts and act with confidence. Strengthening to the auric field, it can be both grounding and energizing at the same time. It helps you channel your energy into productive activities without burning the candle at both ends.

CARE: Clear and charge with sunlight.

TIPS: Carry or wear Tiger's Eye as a talisman of strength. Place it under your pillow to access your dreams for deeper self-knowledge. Place it in the home to attract positive energy.

TOPAZ

ORIGIN: Brazil, India, Pakistan, Namibia, Russia, South Africa, Mexico

COLOR VARIATION: Blue, silver, yellow, gold, champagne. A rarer form is Imperial Topaz, which can be pink, red, or peach-pink.

ELEMENT: Water

CHAKRA: Corresponds to the color of the stone (see the Chakra Color Guide on page 136)

QUALITIES: Focus, clarification, amplification

HEALING PROPERTIES: Topaz is a gemstone that points you toward your goals and helps you distill general ideas into a specific plan of action. Topaz releases the pattern of procrastination and can help you buckle down, especially at the very beginning or very end of a project. Its high frequency keeps delays at bay. When it comes to manifesting your vision, Topaz helps take you the farthest distance in the shortest amount of time. Not a stone for people who like to meander or take the scenic route, it assists with efficiency. When it's time for fine-tuning, Topaz can help you make the adjustments needed and see details that you might have otherwise overlooked. It fights apathy and encourages appreciation for well-executed work.

CARE: Rinse with water. Charge on an altar.

TIPS: Wear Topaz to increase your productivity and help you pay attention to detail. Place it on any chakra to improve its function.

TOURMALINE

ORIGIN: Throughout the world

COLOR VARIATION: Black (Schorl), green, blue, brown (Dravite), pink (Rubelite), pink and green (Watermelon), red and green (Rainbow).

ELEMENT: Earth

CHAKRA: Corresponds to the color of the stone (see the Chakra Color Guide on page 136)

QUALITIES: Deflection, protection, grounding

HEALING PROPERTIES: Tourmaline is considered one of the best stones for psychic protection. It can shield you from anything that's out of alignment for your greatest good. It wards off negativity and clears the residue left by unwelcome visitors, either material or energetic. It is good for sensitive people who need support and structure, as well as high-vibration people who need to come down to earth. It assists with the dispersal of energy knots and clears out obsessive thinking. It can anchor down the energy of a room and keep intruders away. The brown variety, Dravite, is useful when doing shadow work. The most prized is Rainbow Tourmaline, which is red in the center of a green stone and a high-frequency heart activator.

CARE: Rinse with water but do not soak. Pair with Selenite. Charge with sunlight.

TIPS: Wear Black Tourmaline as an amulet to deflect negative energy. Reach for it when you need to release anxiety. Place it in a window to turn away toxic projections.

UNAKITE

ORIGIN: The United States, India, South Africa, Brazil, China

COLOR VARIATION: A blend of green Epidote (page 168), peach Feldspar, and Quartz.

ELEMENT: Water

CHAKRA: Heart, sacral

QUALITIES: Restoration, balance, detoxification

HEALING PROPERTIES: Unakite assists in dealing with fluctuations of moods, energy levels, hormones, appetites, or anything that has a high and low tide. It connects you to nature and encourages the choosing of natural options as opposed to artificial ones. The stone can assist in detoxification and restoring the body back to a healthy natural state. Unakite also connects you to the animal kingdom and can foster animal communication. It carries the energy of fertility and new life and can also be helpful in recovering from sexual trauma. As it links the heart and sacral chakras, it encourages you to create from a place of love.

CARE: Clear and charge on a small dish of herbs, such as sage, rosemary, or mugwort.

TIPS: Incorporate Unakite into your surroundings when you are looking to grow your family, launch a new enterprise, or birth a new project. Keep it on you when you are healing from trauma or abuse, as it radiates unconditional love.

ZEBRA MARBLE

ORIGIN: India

COLOR VARIATION: Black and white stripes containing Dolomite.

ELEMENT: Water, Air

CHAKRA: Crown, root

QUALITIES: Regulation, unity, harmony

HEALING PROPERTIES: A stone of balance, Zebra Marble harmonizes polarities and unites opposites. It balances the yin and yang energies in the body and helps you see both sides of the coin in order to find a win-win solution. Its energy leads opposing forces toward mutual respect, showing that this approach can be better than competitiveness, and the stone can be used to bring what has been separated back together. Zebra Marble teaches the ability to embrace differences by discouraging fear, bigotry, and intolerance. It is useful when working to strike a balance between home and work life, or between relationships and personal privacy.

CARE: Rinse with water. Charge on an altar.

TIPS: Carry Zebra Marble into any situation where people are being too rigid in their mind-sets. Carry or wear Zebra Marble to help you to feel grounded and clear, especially when important decisions need to be made.

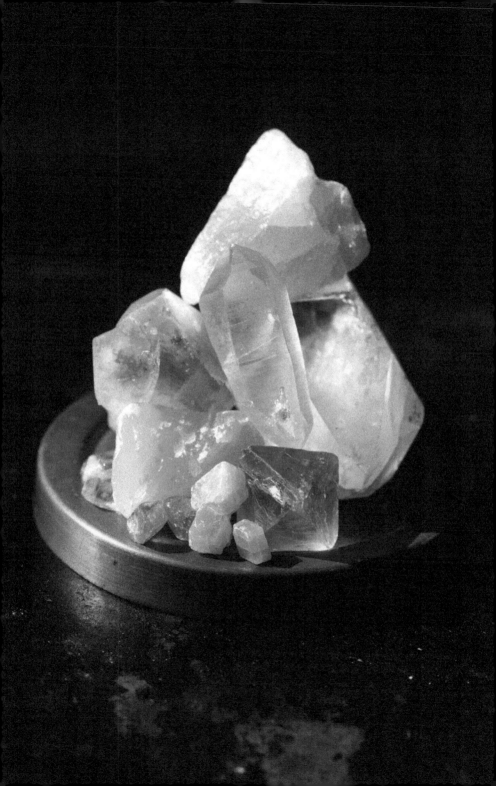

Index

Acknowledgments

Thank you to the following people for their contributions, inspiration, wisdom, and support, which helped this book come into the world: my first crystal guru, M. A. Tippett; my soul family, Marlene and Alex; my parents, Tom and Karin; my friend for life, Tara; my 22 Teachings team: Lesley, Mel, and Frank; my crystal teachers, Michael Cardenas and Patricia Bankins; and my mentors, Dan and William. Gratitude to the House of Intuition and all of my wonderful students. Thank you for the joy and love that you shine into the world as propagators of truth, conduits of light, seekers of wisdom, and vessels for Spirit!

Infinite Blessings,
Naha

About the Author

NAHA ARMÁDY is a lifelong student of esoteric wisdom and an initiate in the Western Mystery Tradition. A full-time teacher, crystal therapist, intuitive consultant, and spiritual mentor at the House of Intuition in Los Angeles, she is also the founder of 22 Teachings School of Hermetic Science and Magical Arts, offering year-round curriculum in crystal healing, tarot, meditation, energy healing, alchemy, sacred geometry, astrology, practical and ritual magic, intuitive development, and hermetic qabalah. Naha strives to awaken her students and clients to develop their gifts and discover their potential, ever conscious of the intentions behind the work and seeking unity with the Divine. "Good magic begins with Groundedness and ends with Gratitude."

Learn more at 22Teachings.com